need to kn...

Digital
photography

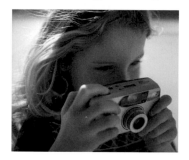

Digital
photography

All the kit, techniques and
tips you need to get you started

Patrick Hook

First published in 2004 by
Collins, an imprint of
HarperCollins*Publishers*
77–85 Fulham Palace Road
Hammersmith, London W6 8JB

The Collins website address is:
www.collins.co.uk

08 07 06 05 04
6 5 4 3 2 1

The majority of photographs in this book were taken by the author.
For a detailed breakdown of photographic credits, see page 191.

A catalogue record for this book is available from the British Library

Created by: Focus Publishing, Sevenoaks, Kent
Project editor: Guy Croton
Editor: Vanessa Townsend
Designer: David Etherington
Project co-ordinator: Caroline Watson
Cover design: Cook Design
Front cover photograph: © Johner/Photonica

ISBN 0 00 718031 4

Colour reproduction by Colourscan, Singapore
Printed and bound by Printing Express Ltd, Hong Kong

contents

getting

started

Not so long ago, the idea of a film-less camera would have been unthinkable. Today, a pocket-sized digital camera is a commonplace item, and digital photography has become a hugely popular hobby. This tour of digital photography begins with the basics, and addresses many questions commonly asked by those new to the subject.

▶ Everyone wants instant communication

The internet has revolutionized communication. People can send and receive text and images on a daily, if not hourly, basis. So why not have instant access to the images we can capture without waiting for a film to develop? Let's take a look at the beginnings of camera technology.

It all began with the camera obscura

The camera obscura was simply a tiny hole in a sheet of material over a window in an otherwise darkened room. Rays of daylight would then project a reversed image of the scene outside the room on the opposite wall.

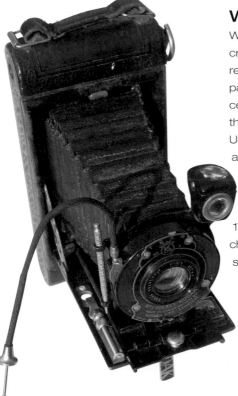

▼ The No. 1 Kodak Pocket camera was a cleverly designed unit which folded up into a relatively compact form. This example dates from around 1927.

Was Vermeer a cheat?

While the camera obscura was capable of creating a faithful image, there was no way of recording it other than manually with a pen or paintbrush. Indeed, it is believed that the 17th century Flemish artist Johannes Vermeer used the camera obscura in just this way. Unfortunately, photosensitive chemicals, the active components in camera film, were not around until the 18th century. The seeds were sown, however, when a light-sensitive chemical was created accidentally in the 1720s from mixing chalk, nitric acid and silver in a flask.

▶ Users could capture some surprisingly high quality photographs with Kodak's Anastigmat F-6.3 lens and cable operated shutter release

▶ Camera clubs and societies were very popular in the early part of the 20th century, and competitions were hotly contested. Prizes included plaques, such as this beautiful cast brass example awarded by the Dover Photographic Society between 1910 and 1920.

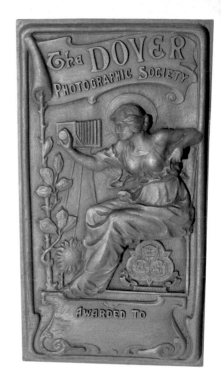

Sunshine and silver

It was not until the early 1800s that such chemicals were used for recording images. One of the early pioneers was Thomas Wedgwood, who made pictures by placing objects onto sheets of leather that had been soaked in silver nitrate, and then left out in the sun. Then in 1816 a camera obscura was constructed which used photosensitive paper.

Daguerreotype process

During the 1830s the processing techniques gradually improved with the use of contact printing and various light sensitive compounds, including silver chloride and silver iodide. One of these early methods was the 'Daguerreotype process', a method developed by the Frenchman Louis Daguerre. This process used highly toxic chemicals, including mercury, to create images on metal plates.

MUST KNOW

The first camera
The 1816 camera obscura could be considered to be the first 'true' camera, although the images formed on the crude paper 'films' were temporary. Over the next ten years the papers were further refined, until in 1826 the problem was finally solved and permanent images became possible.

Wet plates

A much improved commercial process was developed in the 1850s in London called 'wet plate collodion photography'. It was much cheaper than previous methods, since it permitted unlimited reproductions to be made.

Cameras to the masses

Kodak was one of the first big camera companies, producing several pioneering models from the late 1880s onwards. The first examples used

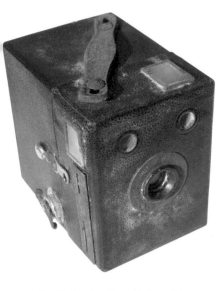

▲ The Kodak Box Brownie brought photography within reach of the masses. While it was little more than a pinhole camera with a shutter and film, it stimulated countless numbers of people to take up the practice of photography.

▼ The desire to make cameras smaller is not a recent phenomenon. The Halina Micro camera from the 1970s used a 110 film – its diminutive size can be seen here propped up on two small coins.

long rolls of paper, but later versions used rolls of film, the most famous of which was the Box Brownie – the first truly mass produced camera in history.

The first colour films

At this stage the images produced were still monochromatic – that is, 'black and white'. The commercial potential of colour film led many companies to spend a lot of time on the search for the right processes, and in 1907 the first commercial colour film was produced. The first multi-layered colour film was introduced in 1936 with the development of Kodachrome.

New electronic technologies

The technology needed to produce digital cameras did not really get going until the early 1950s when the first video tape recorders converted live images from television cameras into digital impulses and saved them onto magnetic tape.

The first digital photographic equipment

The first electronic camera was patented by Texas Instruments in 1972, although it was Sony which actually produced the first commercial electronic camera in the early 1980s. Apple were the first to manufacture a digital camera suitable for the home computer user. This was the Apple QuickTake 100, which came out in February 1994. The following few years saw several rival models produced by Kodak, Casio and Sony.

What is a digital photo?

When a digital photograph is taken, an array of sensors capture the image and convert it into a series of electronic pulses that are stored in a digital form.

A photograph in a file

Electronic pulses are compiled into an electronic file for storage within the digital camera. There are many different formats for this storage, including JPEG, GIF, BMP and TIFF files, which will be examined in more detail later.

The contents of the digital file can be opened with an imaging program such as Jasc's Paint Shop Pro or Adobe's Photoshop, of which more later. These programs can also be used to manipulate the image, if required.

▲ Once you download your images onto a computer, there are various programs available to enhance or manipulate them.

Using digital photographs

Once the image is in the required form – the right size, correct colouring and so on – it may be printed onto paper, imported into electronic documents, used on websites, as screensavers or for publication in magazines and newspapers.

▼ Whatever the subject of a digital photograph, it can be beamed around the world, from just about anywhere, within seconds of being taken.

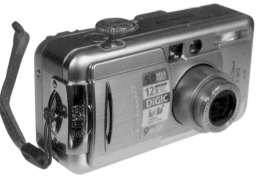
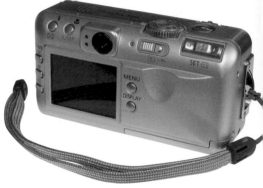

Pixels and quality

The quality of a photograph itself is controlled by a number of factors, including the photographer, and, of course, the equipment used. Where digital cameras are concerned, this is largely dictated by the number of pixels contained within the picture. The word 'pixel' is short for 'picture element', and every digital picture is composed of thousands or even millions of pixels.

▲ The Canon S50 has 5.3 million pixels on offer, but only 5 million are effectively used in the pictures it produces.

Actual vs effective pixels

Most digital cameras that are suitable for the amateur photographer are able to offer up to around 5 million pixels. It is important to understand the difference between the promoted 'actual number of pixels' and the stated 'effective number of pixels'. These are ways of representing how many pixels are available to the prospective camera buyer. What you need to pay attention to is how many are actually used in making up your pictures – the effective number of pixels.

▼ Perhaps the easiest way to understand pixels is to look at a mosaic. The mosaic itself is made up of many individual tiles, each of which corresponds to one pixel. Most digital cameras offer between 2 and 5 million pixels.

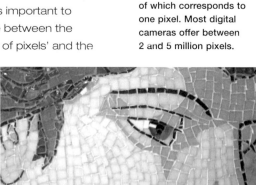

Digital vs film

Until recently, film cameras were better than the digital alternative, since film produced pictures of a far superior quality. However, this has changed with the introduction of higher resolution and reasonably priced digital cameras.

New resolutions

As the cost of digital cameras has plummeted, at the same time resolution has improved enormously. In the early digital cameras, 'resolution' was achieved in two ways: by direct imaging – taking the picture through the lens – and also by using software to 'improve' the quality of the photograph. Unfortunately, many claims were made for this technique, but most were exaggerated. Luckily for those of us who use digital cameras, improvements in sensor technology have meant that we can now choose between many high-quality products that are on offer at affordable prices.

> **MUST KNOW**
>
> **Have a good memory**
> Deciding whether you like the shot enough to keep it is useful if you are short of camera storage space. If the results are poor you can delete the image and free up space on the memory card.

▲ Improvements in digital camera technology have meant that even beginners can take high-quality shots – whatever the situation.

Film favourite for some

The debate over whether to choose a film or a digital camera has now started to swing very much in favour of digital cameras, although there are those who will never agree that film has been matched or even surpassed by today's digital cameras, despite the great expense of having to buy film.

Instant gratification

Digital cameras also favour beginners – not only are they easy to use, but once you have taken a photograph you can look at your results almost instantaneously. With film cameras you would expect to have

to wait for, at best, an hour to get your film developed before knowing whether you chose the best setting for your shot. With digital, you can view the shot straight away – and then retake it if you unwittingly got it wrong the first time...

Critical timing

All is not rosy in the world of digital cameras, however. One of the main criticisms is the time they need to acquire all the information to take a picture, which can often result in the shot being missed. One of the beauties of photography is that it allows a brief moment in time to be captured for posterity. Sadly, this moment can be all too brief, and the slower reaction time of the digital camera may mean that the shutter operates after the event has happened and the moment is missed. While this is often heralded as the great weakness of digital photography, there are ways around it, such as pre-focussing the camera as much as is practicable. If this is done correctly, the camera will respond just as quickly as any film camera.

Bursting the lag problem

There is another method of getting around the 'lag time' of digital cameras, and this is to use a rapid sequence mode. This is where the camera takes a short burst of pictures in quick succession. This can be useful for those occasions when things are happening too quickly to take individual shots, such as when the groom kisses the bride outside the church.

WATCH OUT!

Not too rapid reaction

For very quick shots, the reaction time of the digital focussing mechanism may lead to the shutter operating after the event. If possible, try to pre-focus the camera on an object close to the subject's expected appearance and the camera will respond quickly.

▼ This 35mm film camera is aimed at the entry-level market, but models like this are already losing ground to similarly priced digital cameras.

▲ Before the advent of the rapid sequence mode in digital cameras, capturing this image would be very hit and miss. In this instance, a rapid sequence of shots would be taken and the photographer would then select the best from a series of shots and discard the rest.

No more lost films!

There are many other advantages of becoming a digital camera devotee. For instance, how many of us know someone who has had a film processing company lose one of their films? In some circumstances this can just be annoying, but if the film is of an important occasion like a wedding or funeral, then the loss can be heartbreaking. Likewise, the automated machines used by film processing companies can sometimes malfunction, which may result in the damage or destruction of a customer's film. This is, of course, not an issue with film-less digital cameras. Before the advent of digital cameras, you had no choice if you wanted to process your own films – you needed a darkroom. This is not only expensive, but it also means that you need to find a suitable place to set all the equipment up. These days, all you need is a computer and a few associated peripherals, such as a printer.

▶ Types of cameras

Digital cameras can be divided into three main groups: those for professional use, cameras aimed at the keen amateur and those for the beginner or occasional user.

Wide range of choice

The most expensive cameras are aimed at the professional. While they can produce tremendous results, to use them properly requires a lot of knowledge and experience.

The cameras for the middle of the market are aimed at the keen amateur. These generally offer a variety of modes, but are normally used on 'Auto'. All the settings such as focus and aperture are dealt with automatically, making life easy for the beginner.

The third category is for the economy end of the market. These users normally only use their cameras occasionally. Budget cameras have low resolutions and are fully automatic, so the operator has no control at all over the settings.

Professional-use cameras

The cheaper professional-use cameras have similar resolutions to those aimed at the keen amateur at around 5–6 million pixels, but with greater setting control and much better lenses. At the top end of the market, resolutions exceed 11 million pixels. Most current high-end models will accept film camera lenses.

Amateur-use cameras

These models generally offer a blend of ease of use and reasonably high specification components. For the more experienced operator, they can

16

> **WATCH OUT!**
>
> **File sizes**
> With high resolution cameras, on the highest settings file sizes can be huge – individual pictures can reach over 15MB. Since most of these cameras come with a 32MB memory card, only two images would be stored! Buy additional high capacity cards to store these pictures.

▼ The Canon PowerShot A60 is aimed at the domestic user who wants reasonable quality at an affordable price. It has a resolution of 2 megapixels.

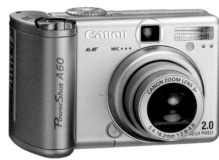

have a lot of settings, but don't have the wide control range of the professional cameras. The better models have in excess of 5 million pixels, but have fully automatic functions for those who are still learning the ropes.

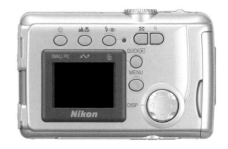

Compact carriers

One of the advantages that cameras in this category have over the professional range is that they are much smaller and lighter, making them more convenient to carry around. One also has to be aware of the value of a professional camera, regarding their security, both in terms of accidental damage and the risk of them being stolen; a smaller camera can be a real bonus here.

▲ The Coolpix range by Nikon offers a variety of highly featured compact models to suit most pockets.

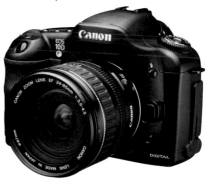

Budget cameras

Budget digital cameras are aimed at those users who are looking to start photography but do not want to spend a fortune before they know what they are doing, as well as the occasional 'snapper'. Choices can be made from among several disposable models, as well as those

▲ The Canon EOS 10D is aimed at the well-heeled amateur or jobbing professional. It has a 6.3 megapixel sensor.

MUST KNOW

The price is right

The choice of digital cameras is vast – and growing more so as the years go on. Decide exactly what you will need your camera for and select your camera accordingly. If you have had no experience even with film cameras, then buying the most expensive digital one on the market will be counter productive.

incorporated into other devices such as mobile phones. These economy models are sometimes known as 'point and shoot cameras' and are mostly intended for taking impulse snaps on the spur of the moment. They are particularly good for taking low resolution shots while on holiday, in the pub with friends or for capturing those precious moments with the kids. As time goes on, cameras will undoubtedly be built into more and more everyday devices, making image capture available wherever.

▶ What you need to get started

In this section we will look at what is needed to spend a day taking photographs. There are lots of accessories available, but most can wait until you know more about what you are doing.

• **Batteries** Whichever model of digital camera you have, sooner or later your batteries are going to run flat. If the batteries for your camera are disposable, it is well worth investing in a set of re-chargeable ones. Battery chargers plug into the mains and will charge a flat battery in an hour or so. In the long run, you will save a lot of money not having to replace disposable batteries.

• **Camera case** A good case is vital to protect your camera from getting damaged. The more expensive types incorporate padding in case they are dropped. Compartments for spare batteries and memory cards are also useful.

• **Memory cards** The general rule of thumb is that you can never have too much memory! Invest in large capacity memory cards when you purchase your camera.

• **Connection leads** The most important connection lead is the one that connects your camera to a computer for downloading pictures. Some digital models will also allow you to upload pictures from your computer back onto the camera – an extremely handy feature if you want to carry specific images with you.

> **WATCH OUT!**
>
> **Running on flat**
> Batteries are guaranteed to run flat at the most inconvenient times, so always be prepared and carry a spare battery pack around with you.

▼ If you get fed up with the weight of your camera, spare a thought for professional film cameramen... On the left is a standard battery for a compact digital camera, and on the right is a battery for a television camera...

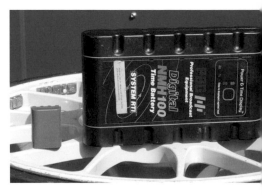

GETTING STARTED

• **Download software** If you purchased your camera new, it will have come with a CD containing all the necessary software for it to communicate with your computer. These programs are simple to use, since they more or less install themselves once the CD is in your computer. If you bought your camera second-hand and the CD is missing, you can normally download the software you need from the manufacturer's website.

• **Image manipulation** There are many different kinds of image manipulating packages available, but if all you want to do is start off by taking some pictures, you will not need these programs yet. We will look at them in more detail later.

• **Computer** There are two main types of computer in use – PCs (which stands for 'personal computers') and Apple Macintoshes. Check whether the operating system – the software which runs the computer – is compatible with the programs that communicate with your camera.

• **Printer** If you already own a computer for domestic or work purposes, the chances are that you will also already own a printer. For really good photo prints, though, you will need a high-quality printer.

• **Scanner** Although a scanner might seem an unlikely piece of kit to have, if you are using image manipulation software for your digitally taken pictures, you can scan in old, faded photographs and improve their quality using the manipulation software. You can then download them onto your camera for taking around with you and sharing with friends and family.

▲ The Canon CP10 is a very small and lightweight printer that can produce high quality credit card sized prints in seconds. The photographs have scratch resistant coatings, making this an ideal way to produce ID cards or pictures of loved ones that can be carried around without getting damaged.

want to know more?

Take it to the next level...

Go to...

▶ **Identifying your needs** – pages 36–40
▶ **Where to buy gear** – pages 42–3
▶ **Ancillary equipment** – pages 44–9

Other sources
▶ **Local photography club**
 you may need to be a member
▶ **Photographic instruction centre**
 many colleges offer courses
▶ **Internet lessons**
 do a search for 'digital photography'
▶ **Computer**
 interactive CD-ROMs
▶ **Publications**
 there are many books on the subject

nuts &

bolts

Digital cameras are fun and generally easy to use. Also, because you no longer need film in order to take photographs, you can forget about having to get your images developed or learning darkroom processing techniques. Indeed, if you are already familiar with computers, then there really is not much to hold you back from mastering the basics very quickly.

Image storage & saving issues

When you take a picture with a digital camera, it is stored in what is known as 'memory'. This is an arrangement of silicon chips that can record information in exactly the same way as computers.

Image storage for your camera

There are several types of digital camera memory, but for the purposes of generalization they can be divided into four basic categories – fixed format, card format, disk format and tape format.

Fixed format memory is sometimes also referred to as 'on-board memory' – basically, it means that the images are stored on hardware that cannot be removed from the camera.

Card format memory is what you will find on the vast majority of medium- to high-price cameras these days. Cards can be removed and replaced in seconds, which allows for large numbers of pictures to be taken without having to return to base to download them.

Disk format refers to mini CDs which are used by some camera manufacturers. From the user's perspective these operate in exactly the same way as memory cards – that is, they can be changed quickly and easily when full (although the storage method itself is very different).

Digital tape format is used on many video cameras, when enormous amounts of digital information have to be stored.

▲ This is a typical digital camera memory card, of the kind that you would find in most compact and professional cameras.

▼ Take too many high-quality, large and detailed close-up pictures like this one, and you might run out of memory!

HOW MANY PICTURES WILL FIT ON MY MEMORY CARD?

This depends on the resolution, size and quality of images. To give an idea of scale, when a Canon S50 is fitted with a 512MB compact flash card, these are the numbers of pictures that will fit on it, at different sizes for three qualities of resolution – Superfine, Fine and Normal.

Large	2,592 x 1,944	Superfine = 198	Fine = 354	Normal = 709
Medium 1	1,600 x 1,200	Superfine = 491	Fine = 879	Normal = 1,734
Medium 2	1,024 x 768	Superfine = 855	Fine = 1,522	Normal = 2,714
Small	640 x 480	Superfine = 1,891	Fine = 3,122	Normal = 5,203

Downloading your photographs

When you have taken your pictures on your digital camera, sooner or later you are going to want to make use of them. However, before you can do this, you need to get them out of the camera. The simplest way to do this is to connect the camera directly to a photo printer, but since this only leaves you with a paper record, we will consider this option later. The more usual method of saving your digital images is by connecting your camera to a computer and then transferring them across. This process is known as 'downloading'. Once you have completed the procedure, you will find that you have quite a choice as to what you do with your pictures!

▼ The size and resolution of the images you take is especially important if you want to apply effects or substantially re-crop an image once you have downloaded it to your computer. In the close-up crop of the girl's face shown below, the image is beginning to break up because the original, complete picture lacks sufficient detail and quality.

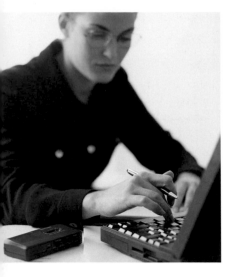

▲ With the right adapters, many memory cards can be plugged directly into a laptop computer for downloading images quickly on the move. However, the computer itself must also have compatible ports and sufficiently up-to-date technology.

▼ The MultiMedia card is a cheaper version of the SD card – it does not have the same security features, but is lighter in weight, making it particularly well-suited to budget applications.

Card types

The number of different memory cards on the market can seem quite bewildering to a newcomer to the subject.

CompactFlash terminology

CompactFlash is the most popular card; these devices are, as the name would suggest, very small. This allows them to be used in many ways – they can be fitted directly into cameras, or with the right adapters can be used in PCMCIA slots in laptop computers. Currently they offer digital media storage sizes up to four gigabytes (4GB).

Flash card storage

Flash cards are memory devices made using solid state computer chips. They have many plus points: they use very little power; they don't require batteries to store your images; and they are very small. On the minus side, however, they do not have the storage capacities of some of the other alternatives.

Microdrives

Microdrives are quite distinct from other memory devices in that instead of using computer chips, they have a rotating disc inside – very much like a micro version of a computer's hard disk drive. This has the benefit of allowing very high storage capacities. Microdrives will not fit all cameras, so buy with care.

SD and MultiMedia cards

SD cards are very similar to CompactFlash cards, but they are physically smaller. Currently they have the same maximum storage capacities at 1GB. There is another version of the SD card available called the MultiMedia card. These are lighter, and are often used in budget cameras and camera phones.

Mini drives

These wonderful devices are sometimes also known as 'data pens'. They are basically tiny units about the size of a key fob. They contain solid state memory, and have a USB plug on one end so that they can be plugged directly into a computer without needing to turn it off and back on again. They are available in sizes from 32MB up to a gigabyte or more. They are not intended to be used as permanent storage, but more as a very convenient way of carrying large amounts of data around.

Storage for your computer

Hard disk drives are available these days with enormous storage capacities – over 200GB units are available. However, if they are your preferred storage method, you will need to ensure that you are not wasting disk space by using inefficient storage formats. My own preference is to keep digital images that I am likely to want to access frequently on a hard disk drive, with a back-up copy kept on CD. It is vitally important to remember that hard disk drives can and do fail – and when they do, everything on them will be lost – so make sure that you have a back-up copy of your pictures somewhere!

▲ If your home or office computer's hard drive is your preferred medium of storage for your images, it is a good idea to keep a back-up of the files as well.

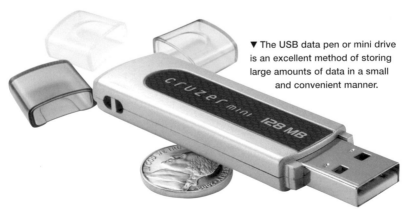

▼ The USB data pen or mini drive is an excellent method of storing large amounts of data in a small and convenient manner.

CDs and DVDs

If you prefer not to cram your computer's hard drive with digital images – or you are worried that it might fail – the most popular alternative storage medium to choose is the compact disc. A compact disc (CD for short) can store 650MB, which is enough for about 50 medium resolution images. CDs have the advantage of being cheap, reliable, easy to use and even easier to store.

There are two basic formats of CD – the usual type, which is known as the 'Recordable CD' and the more versatile 'Re-Writable CD'. When a standard recordable CD is full, you cannot delete files and write new ones to it, whereas files on re-writable CDs can be written and deleted over and over again. This makes the latter useful as temporary storage devices, but since they are many times more expensive than the simpler recordable version, they are not the best solution for multiple CD storage archives.

The DVD (digital video disc) is a derivative of the standard CD with a much larger storage capacity. These discs can accommodate digital video as well as still images.

All CDs and DVDs should be stored in their cases out of direct sunlight and away from heat.

▲ If you have a CD or DVD writer, then you will need the right software to operate it. 'Nero' is one of several CD burning programs available.

WATCH OUT!

CD & DVD care
The recording surface of CDs should be treated very carefully – fingerprints, stains and scratches will degrade the disc, and data could be lost.

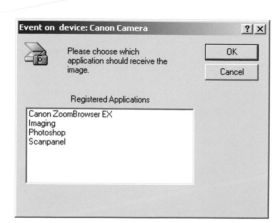

◄ With some digital cameras you can use a special lead to connect to the USB port of your computer. When this is done, the operating system will recognize that a connection has been made, and will show this dialog box asking you to choose which program to start.

Methods of downloading

There are two basic methods of getting your digital images from your camera onto a computer. If your model has a memory card, you have the option of removing it from the camera and plugging it into a card reader – which is itself plugged into your computer. You can also use a download cable to connect the camera to the computer – usually via a slot in the back known as a 'USB port'. This is a quick and simple method.

Before you download your images, you will need to ensure that your computer has the necessary software.

Download software

To install the camera's software, all you have to do is put the CD in the computer and the driver installation program will automatically start up. Then simply follow the instructions on the screen.

▲ Some card readers make use of a high speed connection known as 'FireWire'. Here a reader is shown with a card fitted.

USB and FireWire ports

Once your computer has the necessary software installed, you need to find the right port for the download cable – usually at the back of the computer. Most modern computers have at least two USB ports, and many nowadays also offer a high-speed connection named 'FireWire'.

▼ When a lot of programs start up, they show an image known as a 'splash screen'. This one is for Canon's download package called 'ZoomBrowser'.

Canon

Canon Utilities
ZoomBrowser EX

Folders and filenames

One of the things to watch out for when saving pictures onto your computer is that, unless you are very careful, it can be extremely easy to over-write existing files. This is because some cameras give you little or no control over the filenames of your pictures. For this reason, it is a good idea always to create a new folder when you are saving images. Some camera download software has a 'create new folder' option which you can choose before proceeding.

Another good idea is to add the date to the name you assign to the folder – this is because it is easy to forget that you have already used a name before, and having the date in the names of folders makes it much easier to distinguish between them in the future.

▲ If you accidentally try to create a file with a name that already exists, the operating system will usually intervene and display a message like this, prompting you to re-name your new file.

Image viewing

Once you have successfully saved your images to your computer's hard drive, you will need a method of viewing them. It is possible to use the computer's file manager to display a list of the files; you can then view each file by double-clicking on it, but this is a particularly ponderous process. It is much easier to use a special program to display your images as a series of thumbnails. We will examine these in detail later on.

▼ When you download images to your computer, it is a good idea to create a new folder with a suitable name each time. This will help you to keep track of your photographs in the future.

◄ If you want to upload images from your computer onto your camera, then you will need the necessary software. Canon's ZoomBrowser package is supplied with several of its models. This has a complete upload facility, as shown here.

Uploading images to your camera

Some of the better cameras available – that is, the mid-range models upwards – have the ability to load pictures from your computer onto your camera; this is known as 'uploading'.

Uploading can be a very useful feature. For example, if you are working away from home and have access to a computer, you can download all your images onto the hard drive and view them at large sizes on a monitor. You could then spend several days shooting even more pictures of everything in sight, and by downloading them whenever your cards fill up, you could then reformat the cards each time. This is quicker than erasing the images, and is a good method of cleaning up old memory cards.

Following this procedure means you will never have to worry about running out of card space. It is inevitable, though, that many of your shots will not be good enough to keep. However, when you review them, you can be very selective about which ones you take home, and have the added advantage of being able to upload them to your camera. This method of carrying pictures is also ideal if you want to show a series of images to a group of friends: just connect your camera into a television set with a tv lead, and off you go!

▲ Once the images have been selected for uploading, ZoomBrowser offers you the option to resize them before transferral from your computer to your camera.

▶ Images & pixels

All the digital images that you take are made up of minute individual components named pixels. In order to understand how your images work, you first need to understand pixels.

Megapixels

When buying a digital camera, choose one which offers at least one megapixel. If you can afford a model with more, so much the better. As you get the hang of digital photography, you will soon realize that the higher the resolution your camera is capable of, the better your images will be.

The significance of pixels

Since digital cameras take photographs that are composed entirely of individual pixels, it is worth taking the time to understand their significance. If you are going to take a series of images, it is sensible to set the camera's resolution to suit the purpose of the pictures, and this is where pixels come in. If you are only going to use the images for low resolution situations, such as website advertisements where the file size is likely to be less than 100KB, then there is no point in using a setting that will result in a 15MB file. If you are new to kilobytes (KB) and megabytes (MB), let me explain that there are one thousand kilobytes to every megabyte. That means that for every picture taken at a 15MB resolution, you could have 150 pictures at a 100KB resolution.

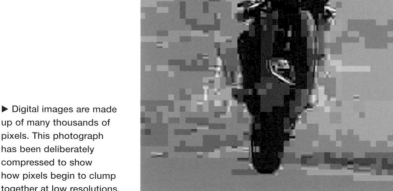

▶ Digital images are made up of many thousands of pixels. This photograph has been deliberately compressed to show how pixels begin to clump together at low resolutions.

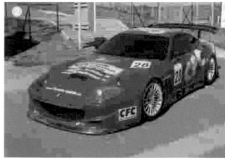

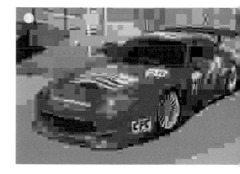

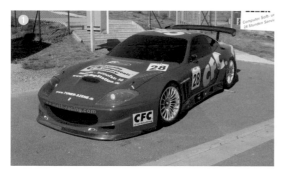

Image compression

If you have a mid-range camera or better, you will probably have a choice of image formats available to you somewhere in its menu structure. The usual choices are between RAW and JPEG formats – most cameras do a certain amount of processing to the images they take before they store them. This reduces the quality of the picture, but increases the number of images you can fit on the memory card.

When a camera processes a picture before storing it, the image is compressed. A good example of image compression is when a photograph is taken of something that has a lot of the same colour in it – for example, the walls of a room. The compression would then be able to reduce the information required to represent the image because it would not have to store a different colour for every part of the picture.

Degradation of images

The most common method of image compression is known as 'lossy' compression, which is used by nearly all digital cameras. Unfortunately, although it produces files which are much smaller than other processes, image quality is degraded at the same time. The extent to which this happens depends on the level of compression applied, and can become a problem if the image is markedly enlarged.

❶ This Ferrari racing car is shown at three levels of compression – firstly with low compression...

❷ ...and then with moderate compression. Here it can be seen that the image is starting to degrade.

❸ Finally, high compression has been applied, and it can be seen clearly that the image is breaking up badly.

Image formats

If you examine a list of computer files, you will see that they are each composed of a name followed by a full stop and three letters. These three letters are known as the 'file extension', and they describe to the computer what sort of file it is dealing with.

Digital images can be stored in several different ways – these are known as 'formats'. Each type is given a different name and the file extension is usually an abbreviation of this.

JPEG or JPG

This is the commonest format for image storage, and is usually the default output type of most cameras. If you want to send an image by e-mail, JPEG format is the one to use unless you have good reason to do otherwise. Anyone with a computer will be able to read a JPEG file, which is not the case with some other available formats.

Bitmap or bmp

The bitmap image format was originally developed for monochromatic images in the days before colour monitors and printers became widely available. Microsoft still uses this format widely.

▼ When you open up a folder you can view the contents as a series of icons or as a list of filenames. To change between layouts, simply click 'View' , and select from icons, details or thumbnails. Here in 'Details', it can be seen that there are 'JPG', 'bmp', 'tif', and 'PSPIMAGE' files – these are all different image formats.

NUTS & BOLTS

◀ Website designers prefer small-size, manageable image formats such as JPEGs or GIFs. These types of files are easy to work with, manipulate and upload or download on the net.

Tag Image File Format or TIFF

The Tag Image File Format makes it possible to produce the very high quality images needed for publication purposes. Unfortunately, files saved in TIFF format tend to be large, so they can be inconvenient to handle.

Graphic Interchange Format or GIF

The Graphic Interchange Format or GIF can produce reasonably high quality images for relatively small file sizes. This has made GIFs very popular with website designers.

RAW

RAW format images are created when a camera stores a photograph with no compression or processing being performed. This means that the image has to be handled by a suitable program if you want to view it on a computer.

want to know more?

Take it to the next level...

Go to...
▶ **Image editing** – pages 78–101
▶ **Printing images** – pages 102–6
▶ **Computer equipment** – pages 112–13

Other sources
▶ **Camera shops**
 will assist with equipment choices
▶ **Manufacturers' websites**
 provide detailed product information
▶ **Product review websites**
 check out impartial product reviews
▶ **Libraries**
 will stock relevant books and magazines
▶ **Consumer magazines**
 detailed product specifications and reviews

buying

gear

One of the advantages of digital photography is that you can zoom in on your downloaded pictures using your editing software. When you do this, sadly the image is not always as crystal clear as it looked on the LCD monitor when you took it. This might be the time to add some decent ancillary gear – perhaps a tripod or a flash gun – to improve your results.

▶ Identifying your needs

While, of course, you want to buy the best equipment you can afford, there is no point in spending a fortune on sophisticated features you may never use. Identify your needs before buying.

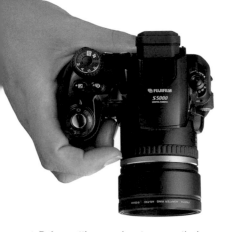

▲ Before setting your heart on a particular model, it is a good idea to go to a camera shop to see whether you can reach the controls comfortably, and whether the overall weight is something that you can live with. And don't forget to allow for the batteries!

Hard choices

Deciding just what you need in a camera may be a simple task for you, or it may be fraught with all manner of caveats, depending on your situation. I recently had to go through this process myself; I needed a camera that I could take on my frequent trips abroad, and so it had to be small enough to be unobtrusive, and yet robust enough to deal with the inevitable knocks and bumps. At the same time, I wanted to be able to take pictures of a high enough resolution that they could be used for publication purposes. It had to function as a point and shoot camera when I was with my family, and yet I also wanted to be able to take close-up shots of wildlife. In a nutshell, I wanted everything, all rolled into one do-it-all camera.

In the end I settled on a 5 megapixel model, which has turned out to be an excellent choice for my needs, although I did have to make certain compromises. For example, I cannot fit a macro lens for really close-up photography, although the camera does have a macro mode, which

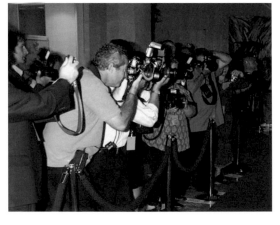

◀ Taking photographs of people need not involve lots of expensive, professional equipment – but it depends what the image is *for*. These paparazzi need the best possible shot.

works well at a distance of half a metre (2ft) or so. I would also like a lot more zoom, but all in all, it is an outstanding piece of equipment.

Resolving your needs

If you are trying to decide which camera model to buy, then I would suggest you first consider what it is you really need it for. Are you mainly going to be photographing your kids? Perhaps you are a keen botanist and would like to be able to capture shots of wildflowers in their natural environment? Either way, you will still need to decide what sort of quality you need. If your images are going to be used purely for websites, then you don't need a high specification camera, and you can save yourself a lot of money; something with 1–2 million pixels (1–2 megapixels) will be more than adequate. If your work is going to be published in magazine or book format, however, then things are very different, and you will need the highest resolution you can afford, with 4 million pixels (4 megapixels) being a sensible minimum.

▲ If you are planning on taking lots of close-up shots of, say, wildflowers, then it makes sense to invest in a camera with a decent macro mode.

▼ If you want to be able to take photographs in any conditions, including under water, then you will need a very durable, waterproof model that is up to the job.

Model looks

Once you have decided what size and weight constraints you need to work within, you need to decide which models of camera you like the look of – the last thing you want to do is to have to carry a camera around all day that you dislike seeing! Style is such a personal thing that only you can make this decision. Some models are available in more than one colour – a choice between black and silver is very common.

Reviewing

Other features to check out are things such as whether you want an LCD viewing screen or not. While these are power hungry items, personally I cannot imagine being without one any more! LCDs tend to be between 4–6cm (1½–2½in) across, although for once size is not everything – the image quality can vary significantly. The most useful thing about having a screen is that you can review pictures as soon as you have taken them. This can save a lot of heartache – that killer shot you just took may in fact be completely unusable due to some unforeseen issue. The auto focus may have picked up on a distant object instead of your intended target, putting it completely out of focus, or your subject may have closed their eyes at the critical

▲ Even if it is only a basic point and click shapshot you are taking, the digital LCD on your camera means you can get it right nearly every time.

◄ On compact digital cameras, you can use the LCD viewing screen for choosing your shot as well as for reviewing your images. This is especially useful, as you can tell a lot more about what the end result will look like than you ever could through a circular viewfinder.

moment. If you check the shot straight away on the LCD screen and find a problem, you can often re-take it with no great drama.

Reaching the controls

Before you go rushing out and buying a particular model, it is vitally important to check that you can hold it properly. People with big hands need to consider whether they can access all the functions without pressing the wrong buttons all the time. Conversely, people with small hands need to ensure that they can reach the controls in the first place! Some manufacturers try to squeeze a lot more controls onto a small camera than is sensible, so make sure the layout is to your liking.

Which platform are you on?

A very important factor to take into account is whether the camera is compatible with your computer's platform (i.e. its operating system). It's no good saving money by going for a bargain offer if you then have to spend three times as much changing or upgrading your computer...

▲ No matter what operating system you use, it is worth making sure that your computer has a good video card and monitor because accurate colour reproduction is important to preserve the quality and integrity of your photographs.

WATCH OUT!

PC or Mac?
If you have a reasonably up to date Windows-based computer, then you can buy just about any camera and equipment you can afford without worries. However, if you have an Apple Macintosh, it might not be compatible with the equipment you prefer, so it is important to check first.

Features and modes

When you have worked out exactly what you want to do with your camera once you have bought it, you will need to check out the models that fit your criteria. This can be a daunting task, as it can seem that every one of them has a range of incomprehensible features and modes. In order to guide you through this maze of jargon, here is a quick guide to the essential terms. Check the Glossary on pages 182–5 for further explanation.

Pixels and resolution

Basically, the more pixels there are in your image, the better the resulting image will be. Two million pixels (2 megapixels) is about the minimum resolution you should settle for in the camera you select unless you only want to take low quality photographs.

Zoom

Beware! There are two types of zoom – optical and digital. Digital zoom is a method of magnifying the image with clever processing techniques, but it falls short of the mark when

▼ If you have ever wondered why it is important to use a suitable resolution setting on your camera, here is the answer. Below are two photographs of a hand-coloured illustration of moths. The image [below left] was taken at 2,592 x 1,944 on a 'Superfine' setting, whereas the image [below right] was taken at 640 x 480 on a 'Normal' setting. From a distance, it is hard to distinguish between the two, but when you zoom in [top images below], the differences are clear to see.

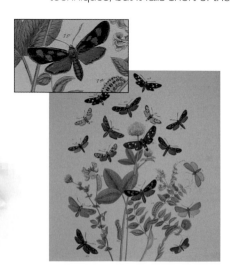

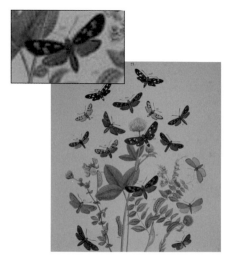

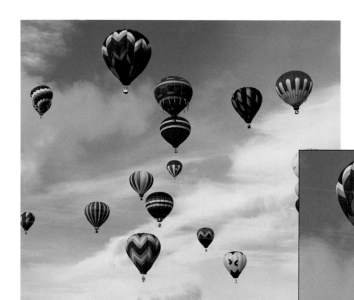

With a high quality optical zoom mode, you will be able to close in effectively on even the most distant objects. In the picture below, only the balloons in the centre of the original image are the subject of the zoom.

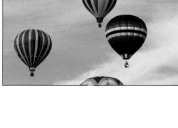

compared to optical zoom, where all the magnification is performed by the camera lens itself. Ideally, go for optical zoom.

Integral flash

Unless you are only ever going to take pictures in well-lit areas, do not even think of buying a camera without a built-in flash or you will end up taking lots of very dark photographs!

Macro mode

If the cameras you are looking at have a zoom facility, the odds are that they will all come with a macro mode. This allows you to take close-up pictures. Choose the best you can afford.

Red-eye reduction

This is a mode in which the flash is fired twice in quick succession, causing the irises of the subject's eyes to close just before the picture is taken, eliminating most of the red eye reflections that are so common in flash photographs.

WATCH OUT!

Other features
Don't be misled by manufacturer's claims or sales patter when it comes to a camera's 'extra' features. Find out exactly what they are for and just who they are aimed at.

▶ Where to buy gear

When the time comes to actually make a purchase, it is very important to ensure that you choose the right place to buy from. There are three main points to bear in mind when choosing your supplier: price, location and aftersales service.

Is it the best price?

Something to watch out for is that while some cameras are advertised as bargain offers, the truth may be that the deal is not as good as it seems. Often you will find that you have to buy much essential ancillary equipment separately. However, many suppliers offer package deals with ancillary equipment included, which can prove far better value for money.

Supplier location and aftersales service

It is important to consider where you will be able to turn if your new camera goes wrong, as digital cameras, like other electrical products, do occasionally malfunction. It may well be worth spending a bit more to buy locally from a reputable dealer than from some unknown website on the other side of the world.

In the first place, you will be able to examine the equipment before you leave the premises. If a camera arrives through the post damaged, who do you blame? It is also a good idea to buy your camera in your own country – for a start the guarantee will cover you, but also you need to think about things like power supply voltages and cable fittings. It is

▼ Geographical issues need to be taken into consideration when buying a camera. For example, if you live on an island, you are likely to be far more interested in mail order than someone who lives in a city.

BUYING GEAR

42

not much use having a nice new shiny toy to play with, but nowhere to plug it in...

The internet

If you do not live near a city, or would prefer not to use a local outlet for whatever reason, then there are many digital photography forums on the internet where you can get very good advice from true enthusiasts about the best websites selling digital cameras. However, before you do business with an internet company, take the time to check out who they are. Take a close look at their contact details – if they don't give an address, be careful. If they give a phone number, check that it is a land line, and not the number of a mobile telephone; if it is, you might be dealing with a fly-by-night operation.

▲ The internet has spawned countless commercial enterprises across the world since its inception, but you should always check carefully who you are dealing with.

Credit cards

If you have a credit card, it is a good idea to use it when you make your purchase, since you will automatically have a certain degree of insurance and other benefits. This is especially true if you are buying over the internet, although always make sure that the outfit you are dealing with has a secure payment connection before doing so.

Mail order

If you read through the magazine adverts, you will soon get a feel for what deals are on offer for the cameras you are interested in – but watch out for steep postage costs and long delivery times.

Doing your homework

At the end of the day, the final decision as to where to buy is down to you, however, it is worth doing your homework if you care about getting value for money. One of the best ways to go about this is to check out the digital camera reviews in photography magazines.

▶ Tripods & monopods

If you are having trouble taking pin-sharp, crystal-clear images, it might be because your hands shake when you hold the camera. A tripod or monopod will solve the problem.

Shaking all over

Blurred images are often caused by camera shake. The best solution to this common problem is to use a tripod or some other method of keeping the camera still at the critical moment. As the name would suggest, a tripod has three legs, although there are variants on the theme such as monopods, which have only one. If you have not used a support device before, it is worth borrowing one to see whether the improvement in picture quality really justifies the cost and inconvenience of buying one and using it regularly.

▶ With legs made from super-light carbon fibre, this Gitzo tripod is aimed at photographers who want maximum performance with the minimum weight.

Stability is all-important

The whole point of a tripod is to provide stability, but if you are going to be taking a lot of pictures on the move – of wildlife, for example – then you will also need one that is light and easy to carry yet very sturdy and resistant to knocks as well.

Whether you decide to buy new or second-hand, it is vital that you check the tripod is stable when it is in position, has sound fittings and will provide the correct height adjustments for your needs.

◀ There are lots of different mounting heads on the market – this is an offset ball head, designed to give the maximum possible range of movement.

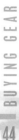

> **WATCH OUT!**
>
> **Head adjustment**
> The platform for the camera at the top of a tripod is known as the 'head'. Take care when adjusting the head, as it is easy to wind it too far and see the camera crash to the floor.

Card readers

A card reader is an essential piece of kit for any serious user of a digital camera. Designed to make your life easier, these little devices are inexpensive and widely available.

Card readers

While it is possible to connect your camera to a computer to download your images, there are likely to be many occasions when this is just not convenient. Maybe the camera's batteries are flat, someone else is using it, or you simply don't have the camera with you – only its memory card. In this case, what you need is a card reader. These are very useful little devices that generally plug into a computer's USB port either directly or via an extension cable.

Size matters

Considering the cost of many camera peripherals, as a rule card readers are good value for money. Most are small enough to fit in your pocket, which makes it practical to carry one with you when you are travelling.

Card compatibility

Many types of card readers are available – some are dedicated to one type of card only, whereas others will accept between two and eight different formats. If your computer's operating system is newer than Windows 98, it is likely that you will not need to install any special drivers, so they can simply be plugged in and used.

▼ Card readers normally connect to a computer through a USB port, as can be seen here.

► Camera batteries

Digital information cannot be stored or transferred without electrical power, so in the case of a portable digital camera its batteries are its lifeblood. Without batteries, it will not work.

Flat batteries

One of the most frustrating things you can experience when using a digital camera is when you are miles from home and your camera's battery suddenly goes flat... There are various things you can do to try to prevent this problem from spoiling your day's photography. The simplest solution is to carry at least one spare battery with you, and to make sure that any you have are fully charged when you leave home.

Other ways of charging

There are other options, but which of these apply to you will depend on the kind of batteries that your camera is able to accept. If you are going to

> **WATCH OUT!**
> **Chargers**
> It is very important that whenever you replenish rechargeable batteries, you use the correct charger, or else you risk damage to both the battery and the charger.

▼ Many aeroplanes now offer USB ports in their seat rests, which can be used by travellers for powering up laptops or re-charging electrical equipment.

◄ Without the correct power source, your camera will not run. All the marvellous versatility of a digital camera disappears without access to electricity.

be using your camera for protracted periods of time in a location without mains electricity, you can always use a car battery charger lead – this plugs into the cigarette lighter socket.

Always get the correct batteries

Many cameras will only accept batteries that were specially made for them by the original manufacturers, in which case you will just have to accept that this is the cost of owning that particular model of camera. Others, generally those in the lower price ranges, will accept a variety of general purpose batteries. It is very important that you select the correct type of batteries for your camera – check with the manufacturer's instructions if in any doubt.

Nickel-metal hydride batteries

Where you have a choice, use NiMH (Nickel-Metal Hydride) batteries. These are designed for equipment like digital cameras which use current very quickly, and will hold about three times the charge of an equivalent NiCd (Nickel-Cadmium) battery. They are also rechargeable, made from non-toxic materials, and over a period of time much cheaper than the alkaline alternatives.

▲ There are lots of different battery chargers on the market, and most are relatively inexpensive. Re-chargeable batteries mean that you do not have to keep buying replacements.

MUST KNOW

Alkaline batteries

Alkaline batteries – either standard or rechargeable – should only be used as an emergency back up, since they will run low extremely quickly and contain toxic chemicals.

▶ Cases & bags

Digital photography is not an especially cheap hobby, so it makes sense to protect your investment in costly electrical equipment by protecting it properly in bespoke cases and bags.

Camera cases, bags and straps

If you go to buy yourself a nice, shiny new camera, make sure that you get a case or bag for it as well! Not only will the camera be a lot safer, but it will be much easier to carry around. There are some things in particular which you will need to protect the camera from, with salt water and fine sand being top of the list.

Bags and cases are available in all sorts of different sizes and styles, with some of the more expensive ones even being designed to be used underwater. Most of the camera manufacturers supply cases for their models, but they are inclined to be more expensive than similar products supplied by specialist companies.

Camera straps are available to go around your neck or your wrist. Wrist straps are excellent for use with small, light cameras.

▲ There are lots of different camera cases on the market, but the best ones offer enough space to carry lots of ancillary equipment as well as the camera.

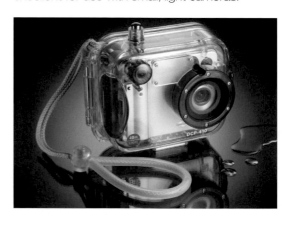

▶ A waterproof underwater housing is available for many different models of digital camera.

Lenses & flash guns

The quality of the lens in your camera has a huge bearing on the quality of the images that you will be able to take. A flash gun can help improve that quality.

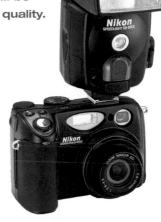

Lenses

The vast majority of digital cameras have no provision for anything but the lens they are supplied with from new. However, the maximum image quality a camera can achieve will be dictated to a great extent by the quality of its lens, so if you have any choice in the matter, go for the best one you can afford.

Aside from the overall quality of the lens, another important feature is focal length; this is measured in millimetres. A lens with a length of less than 35mm is considered to have a short or wide focal length, whereas one over 65mm is considered to be a long or telephoto lens. Sizes in between 35 and 65mm are considered to be normal lenses, with 50mm the most common.

Flash guns

When a photograph is taken in perfect conditions, no extra light is needed. However, those taken at other times will need assistance from some kind of artificial lighting. Normally, this is provided by a flash of some kind. Most digital cameras have an internal flash facility, and while this is fine for general use, you will almost certainly need to supplement it with a flash gun if you want the best possible results.

While flash guns can be used to light subjects indoors or when it is dark, they can also make a big difference in bright sunlight. This is because any strong light source will also cast strong shadows – the clever use of a flash gun can help counteract such darkened areas and improve images.

▲ A flash gun can provide a lot more light when you are shooting in difficult conditions and will improve the quality of your images.

want to know **more?**

Take it to the next level...

Go to...
- ▶ **Types of cameras** – pages 16–17
- ▶ **Printing & computers** – pages 102–14
- ▶ **Digital video cameras** – pages 170–77

Other sources
- ▶ **Electrical goods' retailers**
 stock a wide product range
- ▶ **Local newspapers**
 may have details of clubs to join
- ▶ **Friends and family**
 ask people who own a digital camera
- ▶ **Other books**
 try Amazon websites for relevant books
- ▶ **Product magazines**
 read what the experts have to say

point

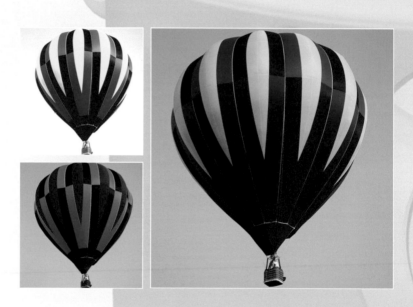

& click

Unless your first digital camera is an economy model with no adjustable features, the range of control settings on offer can seem quite daunting. In this section we examine the controls that you are likely to come across on your digital camera, and discuss what they can do for you when you are composing and taking your images.

Setting digital camera controls

If you have used traditional film cameras before, then you will be familiar with most of the setting controls available on digital equipment. However, if you are completely new to photography, then read on...

Creative control

If you want to do more than produce totally standard images, like to experiment and would love to explore your artistic abilities, then getting to grips with the settings controls on your digital camera will not only be vital, but also potentially a lot of fun! There is a great deal more to most digital cameras than the automatic mode.

But what do these settings control? Here is a brief explanation of what each of them does.

• **Exposure** With manual exposure you can control the amount of light that is allowed to reach the image sensor – this will determine how light or dark your photograph will be once it has been taken. It is controlled by a combination of the aperture size and the shutter speed.

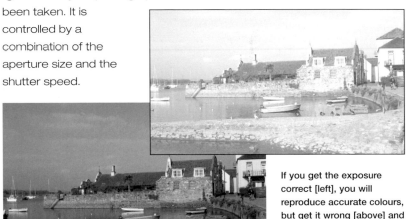

If you get the exposure correct [left], you will reproduce accurate colours, but get it wrong [above] and a washed-out look with pale colours and poor definition will be the result.

- **Focus** With manual focus, you can choose which object or area of your subject you would like to be in sharpest focus. Good focus takes a lot of practice to perfect, but will repay the effort involved with more rewarding photographs.

- **Aperture** The aperture is a small hole behind the lens through which the picture is taken. The size of the hole is varied to allow more or less light in, as needed. Its diameter is measured by what is known as an 'F-stop'.

- **Shutter speed** The time that the shutter remains open for is the shutter speed. The longer the shutter is open, the more light is allowed in, so for low light conditions, it is left open for longer.

- **White balance** You can use the white balance setting to control the light that you are using to illuminate your subject and improve the colours in your image.

- **ISO speed** This measures the camera's light sensitivity. Usually the feature is self-adjusting.

▼ If you want your subject to stand out against its background, it is vital to get the focus and depth of field right. In this image the butterfly is in sharp focus (as shown in the close-up), whereas the background is blurred.

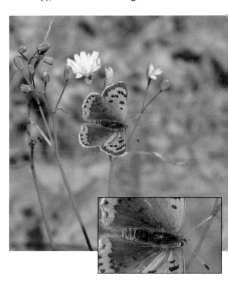

▼ All four images below were taken with a shutter speed of 1/250, and the aperture set to F3.5. It can be seen that as the ISO value is increased, more light is acquired by the sensor, making the image increasingly over-exposed.

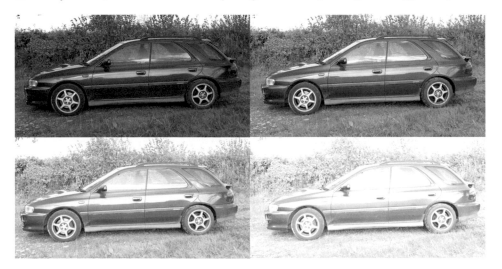

Composing images

There are no hard and fast rules when it comes to composition. There are, however, several general principles which can help take you from being an outright novice to having enough experience to go your own way.

▶ Composing pictures of animals is difficult because they seldom keep still! This photo was taken from a high angle to get the perspective I wanted.

▼ While this scene is not exactly a formal arrangement, to get the most out of your camera you will need to identify what you want to do with it. Set up the shot carefully before you take it.

Horses for courses

The very first thing to consider is why you are taking your picture. Is it to record an event, such as a wedding? If so, the odds are that you will be distributing copies to family members, in which case the recipients will expect to see photographs in the usual format. However, if your images are going to be used in some sort of publication, you may well need to compose your shots to fit in with a 'house style'. In this case, care must be taken to learn exactly what this entails before you begin taking photographs, as many publishers often have very different requirements.

When the final use of your images is not dictated by other people, you can clearly do whatever you want in terms of their composition. This is where you can test your creativity, and in doing so, have a lot of fun. The facility to take and delete photos at will makes digital cameras

particularly suited to this approach – you can experiment to your heart's content without having to worry about throwing away lots of expensive film.

Even if your photographs are purely for your own consumption, it is good practice to discipline yourself always to try for the highest image quality – the sharpest focus, the right exposure, the best lighting, and so on. Unless you are documenting something for technical purposes, every picture you take should be interesting, and its layout should appeal to the eye.

▼ This dramatic action photo was shot from ground level to emphasize the scale of the scene and maximize the movement in the image.

◀ Another way to draw the viewer into your image is to put in lots of interesting detail. How you do this is up to you, and will clearly depend on the environment in which your subject is set. If you use your ingenuity and are not afraid of experimenting you will be surprised at how quickly this becomes second nature.

Grabbing attention

To make your images stand out from the crowd, you need to catch the viewer's attention. You can do this in many ways: by using dramatic colours; by choosing an eye-catching subject; or by framing the subject itself in an unusual or visually stimulating way. This might be achieved with something as simple as a doorway, or by the clever placement of the subject under a bridge, in the mouth of a cave, or between trees.

Background issues

When you are working out your next shot, take a close look at the way the major elements are going to appear in the resulting image before going too far. Strong lines can make or ruin a photograph, depending on how they are used. If you are working outdoors on scenery views, vertical lines can extend from things such as trees, lamp posts or buildings, and horizontal lines can come from horizons, roads, bridges, and so on. If, however, you are working on close-up shots, you need to be a little more careful about objects that you might not otherwise notice until you are back at your computer. For instance, if you are taking macro photography of flowers or fungi, you need to keep an eye out for things like rogue plant stalks, twigs, or even leaves.

Staying on the level

Sooner or later you might want to take some photographs of large expanses of water – rivers, lakes or the ocean. It is one of the unwritten rules of artistry that things that appear level in nature should be portrayed level in pictures and photographs.

When you have a subject that you want to highlight without being too obvious about it, you can play all sorts of visual tricks. For instance, you can use other parts of the scene to lead the eye to your intended element. Roads, tracks, rivers and hedges have all been used to good effect

▼ When you take photographs of things that the eye expects to be horizontal, it is best to ensure that the viewer sees them at the expected angle. For example, this charter angling boat looks all wrong in the first picture below, but as one would expect in the second photograph, with everything level as it should be.

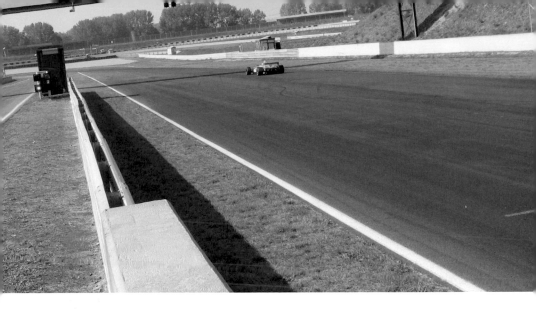

many, many times, so if you can come up with new and exciting ways of doing this, your pictures will score lots of extra points from onlookers! The more subtle the method you use to achieve this, the more effective it is likely to be.

Using space

Once you have got your subject in place and decided on the other important features, it is important to check out the empty spaces in your image. Used incorrectly, they can ruin your picture, but used properly, blank areas can really enhance the message you are trying to convey. For example, if a racing car is entering a long straight, and you want the viewer to see that there is nothing up ahead, show lots of track. Similarly, any other attempt to indicate motion over distance – perhaps images of canoeists, cyclists, aeroplanes, trains and automobiles – can all be improved in this way. If you have no reason to show a large empty area, then find some way of filling it – skies can have clouds and fields can be populated by livestock. No-one need know that these things were all added later using your image manipulation software (see pages 82–101)!

▲ If you want to convey a sense of movement through a landscape, it is a good idea to use space to emphasize the point. Here the enormous size of a motor racing circuit is powerfully portrayed by capturing a racing car in a position that gives a real sense of scale to the place.

MUST KNOW

Shot checklist 1
- Decide on your subject
- Get the camera ready – is the battery charged? Has the memory card got sufficient space on it?
- Set the controls – auto mode/manual mode, etc.
- Await your moment – light, wind, subject placement, position of the camera, weather, etc.

▲ Although there is nothing actually wrong with this shot of a toadstool, the effect of the image is transformed when it is taken from a different viewpoint [above right].

Finding an angle

Another way of exploring your creative side is to make your subject more interesting by presenting it from unusual angles. Rather than taking a portrait from straight ahead, for example, use a chair or step ladder to get above your subject, or crouch down below it. This will immediately make the picture more intrinsically interesting.

If you are going to take a photograph of a tall narrow subject, such as a skyscraper or a pine tree, or a low, wide vista like an open landscape, then it is a good idea to match the aspect ratio of the resulting image to the subject. This is the ratio of the width of a picture to its height. For example, when a picture has an aspect ratio of 1:1, it is square, but at 2:1 it is twice as wide as it is tall. In other words, it helps to make the shape of the picture fit the shape of the subject.

Visual checks

Once you have got your layout and angles sorted out, it is important to check how your subject shows up with respect to the background – if their

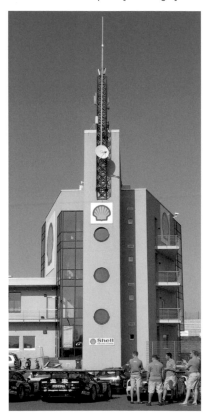

◀ When taking a photograph of a tall, narrow object, it is best to try and ensure that the whole structure can be seen. Chopping the top or bottom off it ruins the effect, so stand far enough back to get it all in. Turning the camera sideways will help.

▲ In this shot, the cropping operation has focussed on the dominant object, but has left too much foreground in the picture.

◀ The cropping in this shot is better, but there is too much space to the left, leaving the main object of interest too far to the right.

▲ The composition of this shot would be fine if it were not for the deep shadowing – the strong contrast between sunny and shady areas has thrown the camera's light metering out.

colours are similar, it may well be that you cannot distinguish one from the other. If so, this photograph will be a wasted effort, unless you can rearrange your angle, the lighting or the depth of field, to make them stand apart.

Balancing acts

Having good visual balance in an image simply means that all the elements in it are well distributed so that it does not look lop-sided, or top- or bottom-heavy. While there are likely to be times when you will want to do this deliberately (such as adding empty space to convey motion), most of the time you will need to be taking balance into account.

Losing your balance

Imbalance can be caused by many things other than object distribution – for instance, a predominance of strong colours on one side of your image can make the other side look dull and empty. Likewise, deep shadows can throw an otherwise well-composed image off balance. If this is the case, you will either need to wait for the light to change naturally, or you will require in-fill from another source, such as a flash gun or electric lamps.

Focus

Getting the focus right is one of the most basic, but most difficult, operations in photography. Not only do you need the right lens in place, but there are a whole host of other factors, such as keeping the camera still while the shutter is open and correctly identifying which part of the image needs to be the sharpest.

▲ Although this picture of my little girl was taken with a disposable film camera, nothing has changed with the advent of digital equipment. When the moment is there, you need to catch it immediately!

Staying in focus

There are two kinds of focus – physical and virtual. Physical focus is achieved using adjustments in the lens position, whereas virtual focus is performed by software in the camera's processor. In other words, lenses do the job properly, for which there is no loss in image quality, whereas digital focus is performed through electronic trickery – the price being that there can be significant picture degradation.

Fixed focus budget cameras

Many budget cameras have no facility for focus adjustment – they do a reasonable job so long as the subject is not too close or too far away. Due to their low prices and acceptable performance, disposable film cameras have become very popular in recent years, and manufacturers were quick to see the commercial opportunities of such economy models. As a result, there are lots of fixed focus digital cameras in the marketplace these days, from super-cheap disposables to those incorporated into mobile phones and other devices.

Auto focus

Once you move up from the budget sector, just about every digital camera has the provision for auto focus. This is a facility where the camera senses how far away the subject is, and sets the

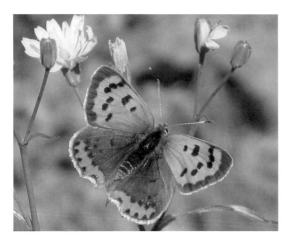

◀ This is a good example of the subject – a Small Copper butterfly – being crystal clear and the background behind it being completely blurred. An effect like this makes the subject totally dominate the scene.

▲ In this shot, the auto focus picked up on the background foliage instead of the subject, a Comma butterfly, ruining the photograph. It pays to set your camera to a central focus point for most of the time.

▼ In this image the Snapdragon flowerheads are in clear focus, but the stone wall behind has lost some of its edge, making the flowers stand out.

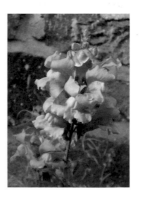

focus accordingly. Unfortunately, your intended subject may not be the same as that the camera identifies; consequently, if you are not careful you can end up with a very blurred picture.

Some of the better cameras allow you to set the focus point, whereas cheaper models will only pick up on whatever is in the centre of the image. This can be a real inconvenience if your subject is off-centre. Many digital cameras can work off multiple focus points, although different models will prioritize the focus point in different ways, such as selecting the one nearest the camera.

Manual focus

If your camera has a manual focus facility, it allows you to disable the camera's auto focus and take full control of matters for yourself. For a start, you can decide for yourself exactly where the focus point is going to be. It is not until you have mastered the art of getting really crisp edges to your subjects that you can start to exploit the depth of field for full dramatic effect. Once you have a good understanding of the focus and aperture controls, you will be able to present crystal clear objects in the foreground and soft, blurry elements in the background.

Exposure

It is clearly vital to make sure that your photographs are not too dark or too light; this is determined by what is known as the image's 'exposure'. When an image receives too much light, it is said to be over-exposed.

Exposure

If an image has too much light in it and becomes over-exposed, this results in a loss of colour. The end result is normally a photograph that, depending on the extent of the over-exposure, may seem to be composed entirely of a series of light greys and whites. Conversely, too little light will produce a dark feel to the image; this is known as under-exposure.

❶ The shutter speed and aperture size determine the amount of light that reaches the image sensor. This photograph was taken with a 1 second shutter speed, which resulted in a completely over-exposed image.

Seeing the light

The actual amount of light that is allowed into the camera and onto the sensor is controlled by two things – the size of the aperture and the amount of time that the shutter is open. When the exposure is being controlled by the camera, all the shutter speed and aperture settings are determined automatically. The camera's processor calculates the correct settings by

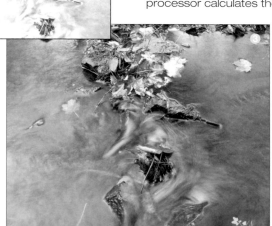

❷ This photograph was taken with a 0.5 second shutter speed – the amount of light entering the camera has been reduced, but it is still very over-exposed.

❸ This photo was taken with a shutter speed of 1/10th of a second. While the amount of light in the image is almost right, there is still too much reflection from the water's surface.

measuring the scene's light levels via a special light-metering sensor. Just how accurately the exposure is determined will depend on many things, but the most important factor is which part of the scene is measured. Most cameras try to account for the fact that the sky is very bright, and so they bias the readings towards the bottom of the picture, but usually give priority to the middle of the scene, on the basis that this is the most likely position for your main subject.

If you are in doubt about how well the automatic exposure setting on your camera is functioning, many models offer an exposure bracketing facility, in which a series of pictures are taken, each with a slightly different exposure. You can then look through them and choose the best image, according to your preferred exposure.

▼ Histograms can be used to analyse the colour content of an image. Here, histograms of the red, blue, green and hue/saturation/lightness components of the image are shown.

Light

One of the most challenging things to get right in digital photography is the light. Not only is it important to get this right for the overall scene, but also for the shadows and detail features in your photographs.

Light temperatures

Photographers often talk about light in terms of its temperature. Light that is biased towards the red end of the spectrum is said to be warmer, whereas that which is shifted towards the blue end is said to be cooler. For example, household electric lights are redder than daylight, which is said to be cooler due to its blue content.

Exposures and light

When photographs are taken in low light conditions, it is necessary to use longer exposure times to capture the maximum amount of available light. Under these circumstances it is vital that the camera is held steady, or else severe blurring will occur. A tripod is the usual answer, but in the absence of one, you may be able to find a stable surface upon

> **WATCH OUT!**
>
> **Variable sensors**
> Image sensors and processors vary from camera to camera – some produce more accurate colours than others. Ensure that the camera you buy has settings you will like.

▼ When the sky is very cloudy as here, it can be difficult to get enough light to take good pictures.

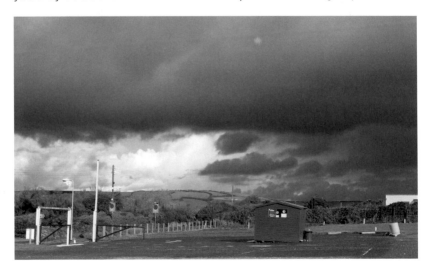

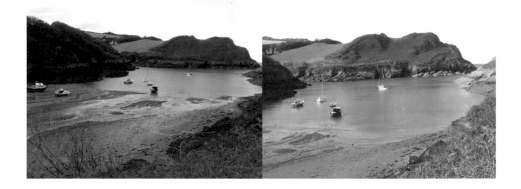

which you can rest the camera. If this is the case, it is a good idea to use the self-timer to trigger the actual shot.

Flash photography

All except the most basic of digital cameras have a built-in flash. Unfortunately, it is only when you

get to the more expensive models that there is the facility to directly control an external flash gun. However, some of the in-built units do have several modes. The default setting is the automatic mode, in which the camera adjusts itself to deal with the ambient light conditions. This can usually be turned on and off very easily to suit the occasion. It is important to remember that the flash needs to recharge between shots; depending on the circumstances, this can take more than ten seconds on a mid-range camera.

▲ Recently, I was asked to get a shot of Watermouth Bay in north Devon, England. However, when I got there, a large mass of cloud was blocking out the sun [above left]. Since the photograph was needed the next day, I had to wait until the sun came out to take the shot [above right]. You can see how long it took for a gap between the clouds to appear by the position of the tide-line.

◀ This shot of an indoor water fountain display at Watermouth Castle in the UK was taken without a flash. The coloured lights give the image an unusual feel.

▲ These stainless steel ice-cream making machines were very reflective to photograph, resulting in a lot of flare from the flash.

▶ Problems with 'red eye'

Anyone who has ever taken a flash photograph of a friend or relative will be familiar with the dreaded problem of 'red eye'. Unfortunately, this common condition occurs just as much in digital photography as with film, but it can be avoided.

Red eye mode

When light strikes the eye, a certain amount of it gets reflected back towards the camera – and in doing so it gets filtered by the internal structures of the machine. In the case of eyes that are adapted for use in daylight, this reflected light shows up as red, whereas in animals whose eyes have adapted to being able to see at night, the reflections may be other colours – such as green in dogs, for example.

The red eye mode available on many digital cameras gets around this problem by giving the eye an initial burst of light, before producing a second flash while it actually takes the picture. The first burst of light causes the iris to close partially, which blocks most of the red light from being 'seen' by the camera.

One thing to take into consideration is that this contraction of the eye can

> **WATCH OUT!**
>
> **Buyer beware**
> Although red eye reduction technology is hardly new – it has been available on many conventional film cameras for years – like some other features, it is not available on all digital cameras. Check the camera specification carefully in order to avoid this problem.

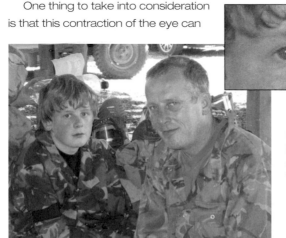

In this shot [left], the flash has resulted in 'red eyes', as can be clearly seen in the close-up [above].

Shot checklist 2

- Find the best angle for your photograph – which perspective will work most effectively?
- Find the right framing/zoom setting for the image – are you close enough to the subject?
- Take the picture(s) – keep your hands steady, take your time, but don't miss the shot
- Review the image(s) – check your focus, light, perspective, etc., using the zoom review
- Decide whether to keep or delete the image – can you get the shot again if it's not right?

▶ In this shot the red eye mode has worked most effectively. The owl's eyes have been rendered in their natural colour, although its stare does have a somewhat bemused quality!

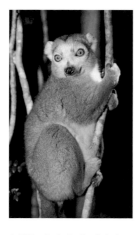

▲ This shot of a bush baby has been back lit so that the use of a flash is not necessary. Once again, the undesirable red eye effect is successfully avoided.

make the person being photographed look less attractive in the resultant image, so if this worries you, do not use the red eye flash mode; instead, remove the red colour in the eyes of the subject by using your image manipulation software on the finished photograph.

There is a further mode now commonly used to control how the flash on digital cameras operates. This is the 'flash synch', and it has two settings, which are known as the '1st and 2nd curtains'. In the '1st curtain' mode, the flash is fired at the beginning of the shutter opening, whereas in the '2nd curtain' mode it is fired just before the shutter closes. Although it operates on a different principle, this feature has the same basic effect as the red eye mode.

Adjusting white balance

As we have already seen, different sources of light can have different colour temperatures. The 'white balance' facility on digital cameras is designed to counter this and to standardize colours.

White balance

The 'white balance' adjustment makes changes based on alterations in the colour of any white objects in the scene. While it is usually performed automatically, you can often over-ride the camera and do the job manually, using several different modes.

• **Auto** In auto mode, the camera deals with any colour balance changes itself.

• **Daylight or sunny** This mode is the best choice when photographing in sunny outdoor locations.

• **Incandescent or tungsten** This mode is the best choice when photographing under incandescent lighting.

• **Fluorescent & fluorescent H** These modes are for use when photographing under fluorescent lighting.

• **Cloudy** This mode is the best choice when photographing in cloudy outdoor locations.

• **Flash** The best choice for flash photography.

• **Manual or custom** This mode lets you set the white balance by aiming the camera at a white object.

◀ These three images of a stone ginger beer jar taken under tungsten light show the results of varying the white balance mode. In the top photograph, the setting was 'AWB' – automatic white balance; in the middle image it was set to 'Flash' mode; and at the bottom it was set to 'Strip Light' mode.

Reviewing & deleting images

Being able to review and delete pictures on the LCD screen of your camera is one of the greatest advantages of digital photography. Depending on how your camera is configured, you can either get a quick review lasting a few seconds each time you take a shot, or you can set it so that you can take as long as you like.

Choosing which images to keep

I review my images firstly to check that the subjects are all in frame. Then I look for any other objects that might have unintentionally ended up in the shot – either in front of, or behind, my main targets. If I am satisfied at this point, I then use the review zoom button to close in on the main parts of the image. Next, I examine the edges of my subject for sharpness. If all is still satisfactory, I then look at the shadows, and check to see if I can make out sufficient detail. The other things I check for depend on the situation; for example, if I am photographing a butterfly, I might have managed to get all the technical details right, but the butterfly might have closed its wings or shifted position as the shutter closed. In this case I will try to re-shoot the image, following the same procedure.

Don't be too hasty with the delete button!

If you have sufficient space on your memory card, don't be too quick to delete an image just because the subject moved. Personally, I try to wait until I have downloaded all my images onto my computer before I delete any of them. Sometimes you can unwittingly capture details that you hadn't realized were there!

▲ Sometimes it is easy to know when an image needs to be deleted... The very blurred image [above, top] came about when the aeroplane hit an air pocket. I tried again once we cleared the air turbulence, and got the shot [above, bottom].

Camera modes

Digital cameras offer several different modes to facilitate many different kinds of photography. As a rule, the more you are able to spend on your camera, the more modes you will enjoy.

Close-up or macro photography

Macro photography is the technical name given to what is more widely known as close-up photography. The subject matter for close-ups is irrelevant – the choice is entirely your own! Many people like to take pictures of natural items in the countryside, as illustrated here – wildflowers, butterflies, fungi, leaves, and many other living things all make excellent subjects.

The right camera

If you have a fixed focus camera, forget it – macro photography will be out of your reach until you obtain more suitable equipment. If you have a mid-range digital camera, you may well have a macro mode, in which case you can make a start in this fascinating field of photography. If you are lucky enough to have a high-end camera, while you may not already own a specialist macro lens, there will certainly be several available to suit your model. Unless you have one of these, you will soon find that there are real

Some compact cameras struggle to acquire a good focus if you get too close to your target. To increase the number of useable shots I get, I use a high resolution and stay a bit further back when I frame the shot [left]. Once I have got the picture I want, I use my imaging software to zoom in on the subject [above].

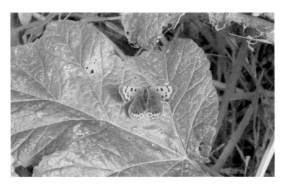

A careful balance needs to be struck with cheaper compacts and cameras with limited macro modes. Take the picture from just too far away [left] and the image will begin to pixellate (break up into dots) when you use your imaging software to zoom in on it [below].

limitations to what you can and cannot achieve. Macro mode on a mid-range digital camera will allow you to capture images from distances of around 10cm (4in) up to about 50cm (20in).

Macro and compacts

Personally, I find that when I use a compact camera, I get the best results when I use the highest resolution setting at distances of around 50cm (20in) than I do when I try to shoot closer up. One of the best things about macro photography is that you can experiment endlessly – the more things you try, the more you will learn, and this on its own may make the exercise worthwhile for you.

Portrait mode

Portrait mode sets the camera up to take images where the subject is in focus, and the background is blurred. We will examine this subject in detail later.

Self-timer mode

The self-timer allows you to take the picture and be in it at the same time. Most digital cameras have this facility. When set to this mode, you simply line the camera up, press the shutter release button, and get into position. The camera will usually beep quietly until it takes the shot.

MUST KNOW
Self-timers

There are other uses for the self-timer mode. For example, a timed release can allow you to improve the sharpness of your images. If you place the camera on a solid object and get it to self-release, you will avoid any camera shake. This method is particularly effective when you are using extremely slow shutter speeds for dramatic effects, such as sports or action photographs.

Auto mode

In the 'Auto' mode, as you would expect, most of the settings are controlled automatically by the digital camera, so if all you want to do is point the camera and take pictures, this is the mode for you. There are, however, several things that you can still do to enhance your images in this mode.

Firstly, you usually have the option to zoom in to the subject. Just how much you choose to zoom will depend on how close you are to the subject and how much of the background you think you should include. If you are in doubt, my suggestion would be to go for a higher resolution than you need, and to include more of the background than is necessary. Then, when you are sitting at your computer having downloaded your images, you can take a more dispassionate view. If you like the background, leave it in – if not, you can keep cropping away until you are happy with the results. Hopefully, because you used a higher resolution, it means that you will not have lost any picture quality by cropping and resizing the image.

▼ This bronze Barbara Hepworth sculpture has been nicely photographed on a fine day – but the subject of the image is off-centre [below left]. However, the problem is easily fixed with a cropping tool in an image manipulation program on your computer [below centre]. And if you want a completely different perspective, just carry on cropping in [below right].

Manual mode

Once you have learnt the basics of how your digital camera works, you may well want to experiment with the photographic special effects that it offers. This is where setting the camera to manual comes in; essentially, this mode hands you control of both the shutter speed and the aperture size.

If you want to take pictures in which you have more control over the settings than the automatic mode allows, but you do not want to have to deal with more than one variable at a time, many digital cameras provide two particular modes to help you along. These are 'aperture priority' and 'shutter speed priority' modes (see below). Depending on the model of camera you are using, the display may well provide certain useful information to make the task easier – for example, by showing the aperture values in red if the image is likely to be under-exposed on its current setting. It is a good idea to follow these indicators until you have enough experience to judge correctly for yourself!

MUST KNOW

Summary of digital camera modes usage
- Automatic mode means that you need never be daunted by your camera
- Experimentation with different digital modes will ultimately make you a better photographer
- Not all cameras offer the same features – shop around before buying
- You needn't spend a fortune to acquire a camera with a good range of modes

Shutter speed priority mode

When the camera is set to shutter speed priority mode, the aperture size is still automatically controlled for the best exposure, but you get full control over the shutter speed. You may choose to do this so that you can set it to a very high speed for capturing moving objects, or alternatively you may want to go for a very slow shutter speed for subjects such as waterfalls.

▶ An ultra-slow shutter speed makes the most of a photograph of a waterfall by conveying the full effect of cascading water and clouds of spray.

Aperture priority mode

When you set the camera to aperture priority mode, it still calculates the best shutter speed to give you the optimal image exposure, but also allows you to adjust the aperture size to suit a particular effect. This can be very useful if you want to play around with depths of field – that is, the relative crispness of objects in the foreground and background of your image.

> **WATCH OUT!**
>
> **Depth of field**
> Controlling the balance between foregrounds and backgrounds in images is one of the hardest aspects of photography. Only practice and patience will make perfect!

Stitch mode

You may well have seen images produced by panoramic film cameras before – such as school photographs, in which several hundred pupils line up in wide, massed ranks so that they can all be photographed together. How many of you remember the weird and wonderful cameras that slowly spun around on rotary mounts as they recorded your unhappy visages? Well, these days most of the better digital cameras can take similar pictures by using what is known as 'stitch' mode. This is where a series of overlapping images are re-processed by the camera into one extra-wide panoramic view.

▼ This is a good example of a panoramic image taken in stitch mode. In this case, three overlapping sections of the overall image have been 'stitched' together digitally. The little girl in red at the left of the picture is the first part of the image, which has been joined up in turn with the sea and swimmers in the middle of the image and the woman in light blue standing on the beach to the right.

Landscape mode

Landscape mode sets the camera up to shoot expansive scenes. It generally does not have quite the same range and flexibility as stitch mode, but it is an ideal medium for taking photographs of countryside scenes and so on.

Low light mode

Low light or night scene mode allows you to capture an image where a close-up subject gets lit by the flash, but the rest of the scene is given a low shutter speed. This lightens the background to make it appear to match the foreground subject.

Auto-rotate mode

If your camera has an auto-rotate mode, it means that an orientation sensor is used to detect which way up the camera was held when a shot was taken. If the mode is in operation, it turns all the images through the appropriate number of degrees so that they are all the same way up when you review them. If you are displaying your images on a television set or computer monitor, this facility can be very useful indeed.

▲ Do not despair if your image turns out like the top one above – misty, dark, indistinct and generally disappointing. The version beneath it has been adjusted using the sharpen, automatic saturation enhancement, brightness and contrast tools in an image manipulation software program on a computer. It is not perfect by any means, but it is much improved, and if this was an important shot of an unrepeatable event such as a wedding, computer image manipulation could save the day.

▲ A colour shot of this castle probably would not be very exciting, but in black-and-white it is striking and moody.

▼ With a sepia effect applied to the image, the mood of the picture becomes almost haunting and spooky.

Photo effects mode

If your camera offers this mode (or one that is similar), you can shoot images with all sorts of interesting and exciting effects.

• **Vivid** This effect enhances the colours and overall contrast to make the image seem brighter and sharper overall.

• **Neutral** This feature does exactly the opposite of the 'Vivid' setting – it tones down the colours and contrast in the image.

• **Low sharpening** This feature reduces the strength of the outlines of the subjects in the image to give them a softer look.

• **Sepia** As you would imagine, sepia mode records the scene in sepia tones instead of full colour, enabling atmospheric image effects.

• Black and white

When this effect is applied, images are recorded in monochrome. Many people think that this is the best way to convey artistic images.

• Custom effects

With the custom setting, you get full control over colour, contrast and image sharpness.

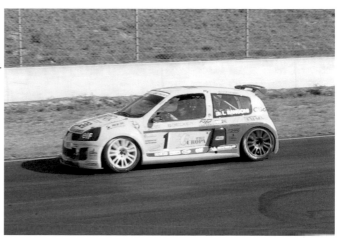

Fast action mode

The fast action mode is used for taking photographs of fast moving subjects such as cars and trains.

▲ When you are photographing fast moving objects such as racing cars, you can use the fast action mode to increase the shutter speed of the camera and thus reduce blurring in the finished image.

Slow action mode

The slow action mode is generally used for creating artistic shots with blurred images of moving objects. It is ideal for photographing running water, especially waterfalls or waves.

Continuous shooting modes

Many digital cameras have their own version of the film camera's motor drive. There are two commonly available versions – low and high speed. Typically, the low speed continuous mode will allow you to see each image on the LCD screen as it is captured, whereas the high speed version does not. These modes are excellent if you want to take a series of shots of some kind of action event – a bowler at a cricket match, an overtaking manoeuvre in a car, a motorcycle or horse race, or simply your kids playing with the family pet! Only video mode (see Chapter 8, 'Digital Video') has greater flexibility.

want to know more?

Take it to the next level...

Go to...
▶ **Archiving images** – pages 80–81
▶ **Image manipulation** – pages 82–98
▶ **Focusing on detail** – pages 99–100

Other sources
▶ **Days out**
 go to places of interest and experiment
▶ **Photography holidays**
 meet other enthusiastic amateurs
▶ **Manufacturer's booklet**
 get to know your camera inside out
▶ **Photographic library websites**
 browse professional images for inspiration
▶ **Photographic organizations**
 contact professionals for advice

image

editing

In this chapter we look at storing and keeping track of your images. We will discuss cropping, resizing and zooming in to make your photographs look more professional, as well as shrinking the file sizes. We will also look at applying effects to your images, and the formats that you may need to share your work with others.

▶ Organizing & archiving your images

The storage methods used on digital cameras are another feature that make them more attractive than film cameras. Since the cards are very small and light, you can easily carry several spares, with enough capacity to hold thousands of images.

Holidays and full cards

When I am away on holiday, I always take more than one memory card with me. I can then go to a camera shop and pay for the images to be downloaded onto a CD whenever the cards start to fill up. This is usually a fairly inexpensive process, and means that I have the image files permanently stored in a lightweight and space-efficient form. Some shops will also provide you with an index sheet as part of the download operation. These have all your shots shown as 'thumbnails' – a mini image of each photo, which is very useful for cross-referencing (see below).

Most people have access to a computer, unless they are away from home, and will generally want to download images themselves.

> **WATCH OUT!**
>
> **Memory lapse**
> High resolution pictures can soon fill up a 32MB memory card. As well as taking a spare card, consider purchasing one with more capacity – anything up to 4GB!

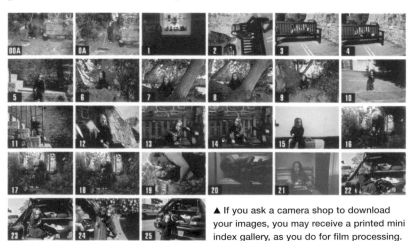

▲ If you ask a camera shop to download your images, you may receive a printed mini index gallery, as you do for film processing.

This is a straightforward operation between most cameras and computers. Typically, a USB lead is plugged from the computer into the camera. The computer automatically detects the camera and opens the downloading program. The images stored on the memory card are shown as a mini gallery.

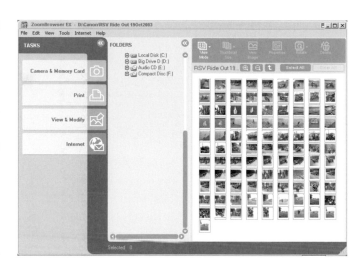

Downloading your images

Download programs will usually offer the facility to select any or all of the images for transferral, as well as the ability to delete any or all of them as desired. This is where a little organization is helpful, since it is easy to end up with a folder containing many hundreds or thousands of images with no immediately obvious way of telling one filename from another.

▲ The download software provided with the Canon PowerShot range is called the 'ZoomBrowser'. Here it shows the images downloaded from a day's shooting.

Keeping track of images

If you have been using your camera for a while, you will find that it is hard to remember which folder holds which images. Create a series of folders with descriptive names and a date to help you. For instance, if a series of photographs has been taken at an event somewhere, call the folder something like 'House Warming Party 18Sept2003'. Use a longhand method for the date, as anyone who uses the internet will be aware that different countries have different date format conventions. In one country, 3/4/03 may represent the 3rd of April 2003, but in another it may represent the 4th of March 2003, which can cause enormous confusion!

MUST KNOW

Creating folders
Think of folders as files in a filing cabinet for storing your images. Files should be clearly labelled to help you find what you are looking for.

▶ Image manipulation

Good image manipulation software makes all the difference when working with digital photographs. Among the two most popular are Adobe Photoshop and Jasc Paint Shop Pro. Photoshop is the more powerful program, although a reduced version (Photoshop Elements or LE) is perfect for the beginner. Paint Shop Pro is less powerful than the full Photoshop version, but more affordable for the keen amateur.

Downsizing images

If you use a high resolution, when you download your images they will be very large. So the first thing to do is shrink them to suit your purposes – this is called 'resizing'. It is a good idea to leave the original image untouched, however, and to save a copy. This way, if you mess up the image, you still have the original from which you can make a further copy.

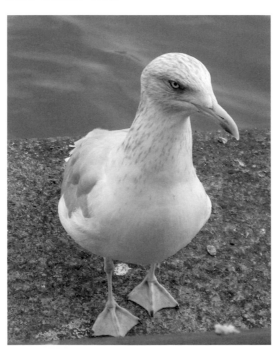

To shrink high resolution images to a manageable size, in Paint Shop Pro, for instance, open up the image, click 'Image', then 'Resize'. A dialog box allows you to set the parameters that control the image size. Save it under another name, or you will lose the original. Here, a friendly seagull [left] has been resized [right].

IMAGE EDITING

82

▲ While the bike looks good, there are bits of litter in the background, so it is time to crop the image down...

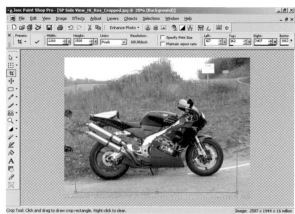

Cropping

Once the image is a manageable size, the next job is to cut any unwanted edges away from the main subject – this is called 'Cropping'. Select the cropping tool from the tool palette. If it isn't visible, go to 'View', select 'Toolbars' and tick the 'Tool Palette' box. The palette will then appear down the left side of the screen. With the cropping tool selected, the mouse cursor will change from an arrow to what looks like two overlapping arrows. Position the cropping tool somewhere on the top left of the image (it doesn't matter where), and hold the left mouse button down. Keeping it down, drag the tool across to somewhere on the bottom right, and then release the button. You now have a thin black rectangle over your image. Using the mouse, position the four sides of the rectangle to correspond with the points where you would like the outside edges to be. When you are happy with the cropping lines, double-click the mouse anywhere on the image. The areas outside the crop lines will be removed and you will be left with a cropped image. If you are not happy with the results, go to 'Edit' and click on 'Undo Crop'. Alternatively, hold down the control key and press the 'z' key.

The image has been opened in Paint Shop Pro, and the crop tool (the red frame) used to set the desired area [top right]. After double-clicking on the image, the program cut away the marked area, leaving the image [below]. Before this was done, the Paint Shop's clone tool was used to remove the blue paint on the ground under the bike, as well as some of the litter that remained in frame.

IMAGE EDITING

83

Compressing the image (in Paint Shop Pro)

If you need to make the file sizes of your images small enough to send by e-mail, or to post on a website, then resizing and cropping your images will indeed make them smaller.

However, there is another way to minimize the file size. This is known as compressing. Open the image in Paint Shop Pro, select 'Edit' and then 'Save As'. A dialog box appears and you will see a button in the bottom right-hand corner of the box labelled 'Options'. If you click this, a second dialog box opens called 'Save Options'. You will see that there is something called a 'slide bar' running from left to right across the box. At the left it says 'Lowest compression, best quality', and at the right it says 'Highest compression, lowest quality'. You will also see that there is an indicator arrow shaped like the

▼ If your photos were taken at a high resolution and are still at full size, they will be far too big to e-mail. We have already seen how resizing the image can reduce this problem. If, however, you want to keep the photo at the same dimensions but still reduce the file size, then use file compression.

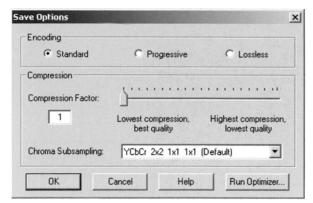

◀ If you want to keep the photo at the same size but still reduce the file size, then use file compression. To do this, open the file up in your graphics program, and find the 'Save As' option. In Paint Shop Pro you are offered a drop-down list called 'Save as type:'. If you look down the list you will see a variety of formats – choose the one you want, and then select 'Options'. In this image we can see the options offered for a JPEG file.

MUST KNOW

Highest quality?

If you want the very highest quality for your image, you have to remember that your file size will not reduce very much. In Paint Shop Pro, if you select 'Lossless' under the Encoding screen (see above), it will not reduce at all. Similarly, in any version of Adobe Photoshop, if you go to 'Image size', choose 'Auto' and select 'Best' quality, then the size of the image will also remain completely unaffected.

end of a house. This can be dragged along the line using the mouse. It is worth experimenting to see exactly what effect this has on your image. Don't forget, however: never experiment with the original file. Always make a spare copy called 'My_Test_Image', for example, just in case it all goes horribly wrong!

The two extremes of the compression scale are easy to define. If you use maximum compression, you will get a very small file, but the quality will be so bad that you may have trouble recognizing it as your image. On the other hand, if you use maximum quality, the image size will hardly change. It is worth spending some time finding out which level of compression will best suit your task.

Photoshop gives the user fewer options – 'Best', 'Good' and 'Draft'. However, this will still achieve an excellent level of compression.

WATCH OUT!

Sliding scale

Be careful when you use the compression slide bar. Changes won't take effect until you next open the image – and it is easy to overcompress without realizing it!

Zooming in

One of the most useful facilities that you will find in all the commercially available graphics packages is the ability to 'home in' on specific parts of your images. This is useful if you have taken a photograph quickly, without giving the final composition of your shot much thought. By zooming in, you can decide whether the focal point of the image is good enough to crop. While it is good to be able to check how sharp the focus is, the really useful aspect is that when you are re-touching an image, you can expand the image until you are looking at individual pixels. In other words, if you have got the time and patience, you can completely rebuild your image from scratch.

Zooming out

The 'zoom out' facility can be very handy if you have an image that needs to be shrunk down for some purpose, such as posting it onto a website. It means that you can look at it on screen at the actual size it is going to end up at before you make any changes. By doing this, you can get an idea as to whether you need to perform any cropping, and whether you can get away with applying any compression without losing too much detail.

> **WATCH OUT!**
>
> **Pixel retouching**
> If you are zooming in on pixels for alteration, ensure the paintbrush tool is fine enough to deal with individual pixels, as otherwise the changes will affect neighbouring pixels.

▼ If you want to focus in on the main subject of an image [below right], before cropping, zoom in to check the sharpness is of good enough quality [below left].

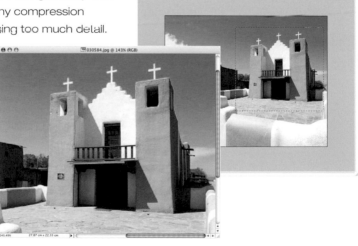

Zooming about

If you want to check the quality of a particular part of the image, then zooming in is the way to do it. If you want to retouch the photo, then it's best to set the zoom magnification to at least 500% so that you can work with individual pixels. If you have a large image and want to fit it all on the screen at the same time, zooming out will allow you to see it in one frame.

Rotate

Some digital cameras will automatically rotate your images so that whichever way up you hold the camera the shot always appears the right way up. If your model is one of these, then you may find you don't need the rotate function to correct the image's positions, unless you had 'auto-rotate' switched off for some reason. If the shot you took has come out slightly skewed and not aligned to the horizon, for example, then you can make simple adjustments through the 'Image' menu, scrolling down to 'Rotate Canvas'. Here you can straighten an image by whole or minute degrees. You can also produce some great visual effects by shifting the horizontal axis or mirroring the image.

The rotate tool is great for re-aligning images that have been taken with the camera held at unusual angles – either by accident or by design – but it can also be used for artistic purposes as well.

Saving images in specific formats

If you are sending your images off to other people for use in websites, glossy magazines, enthusiast publications, or by family and friends, sooner or later you are going to be asked to use an image format that you are not familiar with. It may be that your camera saves images in the JPEG format, for instance, and a magazine has asked you to supply images in the TIFF format, since this is what the publishing industry usually works with. If this is the case, find the original file (the unadulterated image) and make a further copy of it. You need to do this because if you have resized or compressed the image you will have lost a lot of the detail, and magazines need the highest possible quality for reproduction.

Open this copied original, go to 'Edit', and click 'Save As'. This will produce a dialog box, with a drop-down list labelled as 'Save As Type:'. Explore the list of formats available to you, select the appropriate one, and then click 'Save' – and that is all there is to format conversion!

▼ In order to retain the full quality of your original image, you need to be careful about which format you save it in. For example, the 16.7 million colours in a TIFF file reduces to only 250 if it is re-saved as a GIF, resulting in a massive loss of overall picture quality.

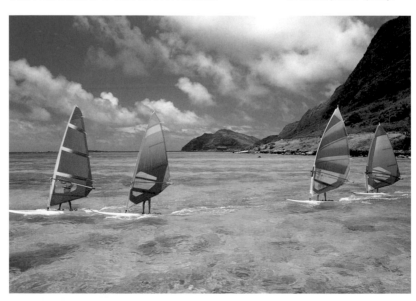

Blank out a number plate

You want to publish some photographs of a motorcycle on a website, but for security reasons, you do not want the number plate to appear. Firstly, resize and crop the image, saving it at the amount of compression that makes the image usable. In your graphics package, make sure you have the tool, colour and control palettes visible. Select the paintbrush tool and use the controls palette to choose the shape and size of the paintbrush. I have chosen a round brush, 4 pixels wide. Next, choose the colour to 'paint' out the figures. Position the mouse pointer over the colour palette; as you move it around, the current colour is shown in a small box below the palette. When you have found the colour you want, click on it, and your chosen colour is displayed. Now you start painting by clicking on the image and dragging the paintbrush around until you have coloured over the figures. If you need to change colours, just follow the same procedure.

▲ In the top image on this page we show a motorcycle with its number plate partly blanked out. Beneath this first image, we show the same image with the numbers completely blanked out. This prevents the registration number from being traced, making the image safe to publish. It is a good idea to do this whenever you make images of bikes or cars public.

▲ Above is the window which shows the various palettes needed to paint out the number plate. Down the left, the paintbrush tool is chosen ❶ and the controls palette is open ❷, so you can choose the size of the brush. On the right-hand side at the top is the colour palette ❸ and below is the box showing the colour of the number plate, ❹.

Blowing in the wind...

There are a lot more things that can be done with a graphics package than painting out letters. For instance, I recently took this night shot in Portugal of some ornamental grasses blowing in the wind. I used a long exposure to give them a blurred effect. If you have an artistic flair, or think you may have, it is well worth taking an image and experimenting with all the effects your particular graphics program can produce. The more recent releases have a stunning array of options that can make a huge difference to an image, but when they are combined, the sky is the limit! For a start, have you thought about what an image that is shot at night might look like when seen as a negative?

◄ As it stands, this picture does not exactly grab your attention, but look what happens when you add some special effects (these were all done in Paint Shop Pro). Below, the same shot is modified with a chrome effect, and opposite, a fade correction is applied.

▶ The chrome effect converts the image to what is known as a greyscale format. Effectively it is black and white, but it also does all sorts of other strange things. Notice how the spotlight goes from being a bright object to one that is completely black. The grasses themselves have been highlighted, and their stalks show up well.

▼ The fade correction has changed the colours dramatically – it has really brought out the greens in the grasses, but also added a blue haze around the flowerheads. Both of these effects can be adjusted in tiny increments, so that you can see what is happening as they are applied. If you don't like the look, use the 'Undo' facility and try again with something else.

▲ This is the same scene converted to a negative image. It is not very interesting, but does show promise. You could, for instance, convert an image to a negative form, and then include certain parts of it in a 'normal' photo.

▼ An alternative to just applying a negative effect to the image is to apply another style on top of it. This version is a negative with a coloured foil effect applied. There are so many different effects available that you could spend all your time trying out different combinations!

▲ This version of the image has had the 'contour effect' applied to it. If you want to try something really surreal, it may be the ideal tool for the job!

MUST KNOW

Choosing an effect

Graphics packages can vary in the amount of effects they offer the user. In Photoshop, these effects come under 'Filters' and, depending on the version, will differ in the amount on offer. For example, the more expensive, full version of the program will offer a lot more variety than the entry level Photoshop Elements. However, the basic program is more than sufficient for the beginner.

Drawing attention

Sometimes when you look at your finished work, you may decide that the subject – or focal point – of the image is unclear and you would like to give this feature more emphasis. Rather than simply cropping in to a feature in your photograph, which then effectively removes the rest of the image, you may wish to retain the entire scene but highlight the main focal point of interest.

In Paint Shop Pro, an effect that can draw attention to a particular element in your image is adding a magnifying lens. As with most of the other manipulation tricks that can be applied to an image in this software package, this effect can be adjusted to the smallest degree. This means that you are in control as to how big the magnifying lens appears and what degree of magnification is applied to the important element.

◀ Here, we see a racing driver on the starting grid. To emphasize the fact that the woman holding the flag is our point of interest, we can add a magnifying lens, homing in on her face, yet still retaining the rest of the image at the racing circuit.

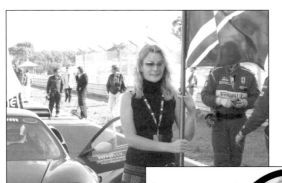

▶ With the lens added, there is no doubt as to the main interest of this image.

IMAGE EDITING

92

▲ In this image [right] I have used the 'Red eye removal tool'. As mentioned previously, using the red eye setting on the camera makes the pupil shrink, which can make the subject appear aggressive. In my opinion, it is much better if you do not use it, and instead remove the red using your graphics software package.

Getting framed

Once you have resized, cropped and compressed your image, you might want to give it a fancy frame. Here (above left) we have a picture of someone cleaning their mask mid-way through a paintballing session. In order to give the image a documentary feel, I have added a film slide effect, using the 'Picture Frame' command in Paint Shop Pro. We also have to face up to the fact that the flash has caused the famous 'red eye' effect, which has been removed using a graphics package.

Most graphics packages come with a variety of picture framing functions, including the film slide frame. Other framing styles include various picture frame effects – both modern and traditional, soft-focus frames – in many shapes, as well as a 'ripped-paper' effect to look as if the image has been torn from the page.

Getting rid of red eye

Lots of digital cameras on the market come
with a red eye removal feature (see page 66).
However, if your camera does not, then you can
easily remove this common problem by using
image editing software. Most of these programs
use a dedicated red eye removal feature (Paint
Shop Pro is shown on this page, but the later
versions of Photoshop Elements also offer this
feature). You can perform the function manually
as well by zooming in on the individual pixels and
recolouring them.

Here we can see the red eye removal tool
at work on the subject's eyes, removing the
red elements around her pupils.

▼ A close-up shows the red
eye problem.

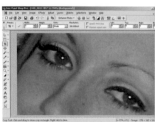

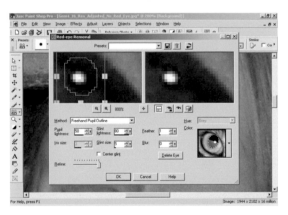

◄ The red eye tool in Paint
Shop Pro has several modes
that allow you to zoom in and
remove the red elements
from the eye. In this instance,
I have used the freehand
outline facility to specify the
area for attention. In the left
window pane I have drawn
around the reds, and the
right window pane shows
the results. Note that you can
set several other parameters
as well, including the
lightness and sizes of the
pupil, and glint.

◄ And here is the resultant
picture – minus red eye.

▲ Here, a photograph of a soft, cuddly reindeer toy is untouched, with all its features in proportion to one another...

▶ ...however, apply some rather unsubtle distortion, and it becomes a curiously mutated, monster reindeer!

Distorting the truth

There are numerous effects that can be achieved using the inbuilt features of most image manipulation software. That said, there are hundreds – possibly thousands – of additional features that you can buy or download free from the internet or from a 'freebie' in a magazine.

Here, we have an example of image distortion. In this instance I have used an add-in (plug-in) for Paint Shop Pro called 'Gloop'. As you can see, you can make all sorts of alterations to any part of the image. I didn't have the heart to do this to any of my friends, so I picked on a harmless little reindeer instead...

Set in stone?

Photoshop comes with its own equivalent to Paint Shop Pro's 'Gloop' effect. With the 'Liquify' filter, you can distort any part of an image, making the image look as if it has turned to liquid. In Photoshop Elements, go to the 'Filter' menu, find 'Liquify' in the pull-down menu and apply the liquify filter to whatever area you select on an image. With the cursor pressed down where you want the distortion to start, simply drag the particular feature to where you think is suitable within the image. As you can see from the images on these pages, it is great fun to play around with.

Facial features lend themselves well to this effect, giving the caricature a whole new lease of life! In the fuller versions of Photoshop, there are even more options such as Warp, Twirl and Pucker to enhance the liquify effect.

◄ A swimmer performing the butterfly stroke looks impressive, but what could make him go even faster, just for fun?

▶ An added pair of flippers should do the trick nicely!

IMAGE EDITING

○ ○ ○ 🖼 080016C.jpg @ 100% (RGB)

100% 12.95 cm x 16.12 cm ▶

○ ○ ○ 🖼 080016C.jpg @ 100% (RGB)

100% 12.95 cm x 16.12 cm ▶

▲ An ordinary family group picture can be given a fun 'hall of mirrors' effect by applying the Pinch filter with a positive value. This is a great trick for jokey e-mails, or maybe birthday and Christmas cards.

Stretch it out

Another distortion filter that comes with most image manipulation software is the 'Pinch' effect. As its name suggests, it is almost as if a point of an image stretches or squeezes the entire image from the point of selection.
In Photoshop Elements, when you choose 'Pinch' – which is found in the Filter menu under 'Distort' – a sliding scale bar will appear, as well as the part of the image to be distorted. The image snapshot allows you to gauge in real time what the overall effect will be when certain levels of pinch are applied.

The scale values in Pinch range from -100 to +100. Positive values squeeze the distortion towards the centre of the image; negative values shift or extrude it outwards. Since you have a snapshot of the image in the dialog box, you can afford to spend a little time squeezing or extruding the image until you have applied the distortion exactly as you want it.

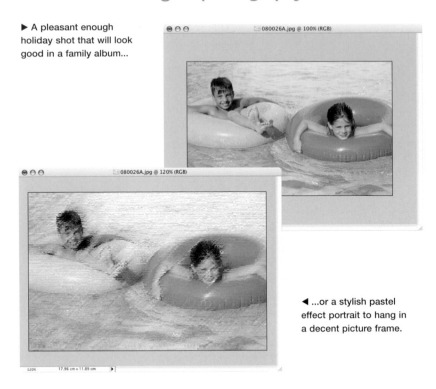

▶ A pleasant enough holiday shot that will look good in a family album...

◀ ...or a stylish pastel effect portrait to hang in a decent picture frame.

Artistic flair

Nowadays, image editing software is so sophisticated that it can take our photographs back to a time before cameras were invented and turn them into veritable works of art. Various artistic filters are available, producing effects that the finest Impressionist master would be proud of! The features produced include: a charcoal drawing effect; a crayon or pencil drawing effect; a filter that turns a picture into an oil painting or a watercolour; a sponge or smudge stick effect; and a rough pastel filter, which is the effect shown here.

When you select any of these filters, you are given the option of how much of the effect you wish to apply to your image. The choice, of course, is up to you and will depend on the type of stylized effect that you wish to achieve.

Colour me... anything you like

Another effective manipulation technique is to replace the actual colours of an image with vastly different shades to create a completely different feel to an image, as we can see below in this picture of giraffes on the savannah at sunset.

In Photoshop Elements, by choosing 'Replace Color', a dialog box appears. Click on the colour you want to replace in the preview window, then in the Transform section of the box, move the Hue slider scale to change the colour – in this case from orange to blue. Experiment with the Saturation and Lightness sliders until you have achieved the desired effect (you will see this in real time, as the Sample swatch will change while you are moving the sliders).

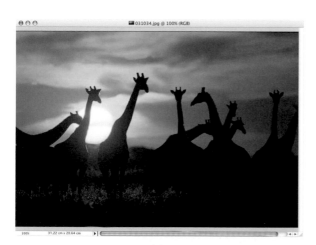

◄ An atmospheric safari shot of giraffes silhouetted in the dying light of sunset. A picture of them taken in the moonlight would look wonderful, but what if you cannot guarantee they will still be there?

▶ No need to wait around until midnight – simply replace the colour and you have an identical night shot. You may have to retouch the colour around the sun, as there were elements of orange light reflected onto the giraffes' necks in the original.

Detail, detail, detail

Inevitably, when you have downloaded your images onto the computer and open them up to view them, you may be a little disappointed by the lack of sharpness of some. The detail of certain parts of the image may not have come out as clearly as you would have liked. Have no fear – image editing software is here! The Sharpen menu will pull pixels together, improving the definition of a fuzzy or hazy looking image. Sharpen More or Sharpen Edges may improve the image. However, it may make it look pixelated and even lose its resolution. Again, experiment with an image. You can always press Apple Z or Control Z to undo any changes to the image.

▼ Below is the final image, as opposed to the original picture [left]. The original did not have much definition to the brickwork or ornamentation around the doorway, which the sharpened image now shows clearly.

080048D.jpg @ 100% (RGB)
080048D.jpg @ 100% (RGB)
100% 11.96 cm x 17.99 cm
100% 11.96 cm x 17.99 cm

▲ The image on the left seems to be lacking in colour depth and does not give the scene any vitality. However, once the colours have been saturated in the editing software, the picture becomes much more intense.

Saturation point

Another problem that you may have with your digital images is that they sometimes appear slightly washed out. This generally means that the colour is not as vibrant as you remember when you took the photograph in the first place. In Photoshop Elements, pull down the Enhance menu, go to Colour and select Hue/Saturation. In the dialog box, slide the Saturation scale to the right to increase the intensity of the colours. This will affect all colours in the image. If you wanted to concentrate on skin tones, for example, in the Edit menu at the top of the dialog box, select Reds and again slide the Saturation scale slightly to the left to adjust the tones. The picture will change visibly as you perform any adjustments.

want to know **more?**

Take it to the next level...

Go to...
▶ **Image storage** – pages 22–9
▶ **Images and pixels** – page 30
▶ **Image compression** – page 31

Other sources
▶ **Photography exhibitions**
 will give you artistic inspiration
▶ **Photographic clubs**
 many offer training in special techniques
▶ **Learning on the net**
 do a search for 'image manipulation'
▶ **Using graphics programs**
 practise with tutorials and projects
▶ **Publications**
 photo art books and magazines

pixels

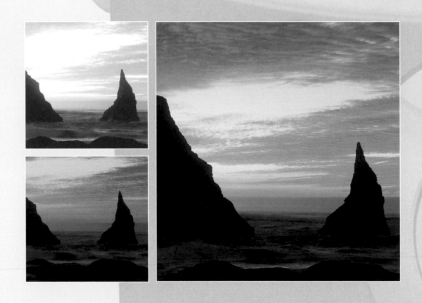

to print

You are likely to want to print your photographs at some stage. In this chapter, we look at printers – what types there are, what kind of paper to use and the ink cartridges you will need. Most equipment is useless without a computer to connect to, so we also discuss the various types, the software, how to stay virus-free and backing-up work.

Printers

Most of us who take digital photographs will want to print them on to paper for display in albums or picture frames at some stage, in order to make the most of our images.

Unless you are prepared to pay for someone else to provide image printing as a service – for example, a specialized photographic shop – sooner or later you are going to need to buy a printer and learn a little about the subject of printing. Broadly speaking, getting good prints of images is reliant on two things – the quality of the printer and the quality of the paper. This naturally assumes that the image itself is up to scratch in the first place! However, once you have used many of the manipulation techniques discussed in Chapter 5, 'Image Editing', this issue should not enter into the equation.

Printer types

Printers come in many forms: dot matrix, inkjet, bubble jet and laser are the most common types. Dot matrix printers are really only suitable

◄ This economical bubble jet printer can print around six sheets of text per minute. It can also produce colour prints, although they are not up to the same output quality as those of more expensive photo printers.

PIXELS TO PRINT

Portable prints

Printers small enough to carry around and connect up with a digital camera are increasingly popular as their cost becomes ever more affordable. They carry around 20–30 sheets of photo paper in their paper cassette. Most offer a process called dye sublimation, which uses a ribbon containing transparent dyes that are heated over the printhead and onto the paper.

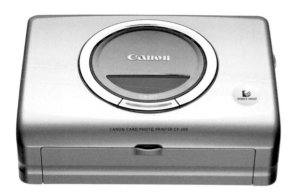

◀ The CP-300 Canon Card Photo Printer is a truly portable device in that it can be run from battery power. It can produce prints from the size of credit cards up to 15 x 10cm (6 x 4in) at a resolution of 300dpi and can be used directly from the camera.

WATCH OUT!

Price vs speed

Generally, inkjet printers are cheaper than lasers. However, a drawback is that they are considerably slower, which may be a problem if you are printing lots of photos.

for simple text output – things like shop receipts are often produced in this manner. Laser printers produce the highest quality prints, but while the black and white versions are practical for home use, colour versions can be very expensive. The most suitable choice for producing high quality photographic prints in the home is the inkjet printer, which uses a cartridge to drop ink directly onto the paper. Bubble jet printers, which are often cheaper, use special heating elements to prepare the ink. The quality is not as good as that of inkjets or lasers and they tend to be slower to print. Additionally, the ink of both bubble and inkjet printers tends to smudge on inexpensive paper (see pages 108–109 for more on paper).

Portable printers that link straight to the camera are also available; these are known as photo printers. These devices are invaluable for printing out hard copies of your photos if you are away from a computer for any length of time.

Toner cartridges

These contain special types of ink used by laser printers. Toner is a dry, powdery substance that is electrically charged so that it sticks to a piece of paper charged with the opposite polarity. For most laser printers, the toner comes in a cartridge that you insert into the printer. When the cartridge is empty, you can replace it or have it refilled. Do not forget to recycle your old cartridges.

Printer cartridges

No matter which type of printer you decide to use, to produce your image onto a sheet of photographic paper as a print it will need ink – and ink comes in the form of cartridges.

Inkjets

Inkjet printers use two cartridges to supply the ink – one for black and the other for colour. Of the two, the black is cheaper to purchase than the colour cartridge. Most printers come with software that allows you to monitor the levels of ink. This can prove to be very useful, because you get advanced warning that you need to get spare cartridges before they actually run out. It would be extremely frustrating to be in the middle of printing off some of your digital pictures for a friend, who has to leave shortly, when the printer comes to an abrupt halt and flashes up a 'run out of ink' message!

▼ Colour cartridges are often made up of three colours, which are blended together to produce the different shades that make up a colour photo print.

Cartridge replacement

When a cartridge runs out, replacement is extremely straightforward on most printers. New cartridges are available from the original manufacturer, but can be rather expensive. Cheaper alternatives are often supplied by discount companies that specialize in undercutting the manufacturers. Many of these

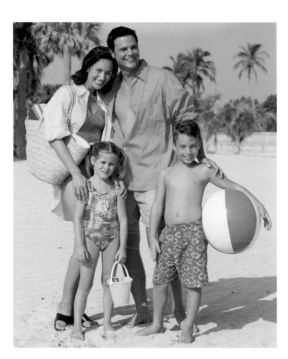

◄ There is often a startling difference between the colour definition achieved by using high quality ink cartridges [left] and poor quality, cheaper ink cartridges [below].

companies will have a site on the internet, so you can send off for cartridges through mail order and receive your replacements generally within about a week. However, the old adage that 'you only get what you pay for' is worth remembering. Certain generic brands do not last as long and are not of the same high quality ink as those of the manufacturer's own-brand ink cartridges. This is fine for colour printing onto normal copier paper, but very noticeable when printing images onto high quality photo paper. The colour can vary and will cancel out all your hard work of retouching or enhancing the colour resolution of your images.

Some people keep their empty ink cartridges for re-filling, either by a professional outfit or with a 'do it yourself' home refill kit. The latter can involve a messy process, but a budget user who is prepared to get their hands dirty can make a real saving over the cost of buying new cartridges.

WATCH OUT!

Storage
As well as keeping extra cartridges in a cool, dry place, always check the 'use by' date, because ink within the cartridges can deteriorate badly if kept for a long time.

Putting print to paper

Paper comes in many forms, but the two main variables are its finish and weight. The quality of paper suitable for printers is mainly dictated by the type of coating used – and its thickness.

Types of paper

The paper used for domestic purposes, such as printing out letters, is typically 80gsm, with 100gsm being a thicker, but more expensive alternative. High quality paper is available for photographic purposes and generally comes in small packs of between 25 and 100 sheets, as opposed to packs of 500 sheets in the case of general purpose paper. Photographic paper generally has a glossy coating on one side. Load the paper into the printer so that this is the side which the print ends up on, as otherwise the quality of the print will be considerably degraded!

If you normally use general purpose paper, whenever you want to use special purpose media such as photo quality film, you must reset the printer properties to let it know that you are using something different; otherwise, your prints will look very mediocre. To do this, click 'File', then 'Print', followed by 'Properties' or 'Options'.

▲ Always check the labels of products carefully to make sure that the paper you are buying is the correct type for your needs.

WATCH OUT!

Paper effects

As with quality, your final print will differ according to the type of paper used. These different types include canvas, linen, matt or glossy, so choose your paper carefully!

◄ If you have a photo quality printer, you will need to ensure that you use the right kind of paper, such as this photo paper [left], when printing your photographs out or else you may get extremely poor results.

Under 'Media type', you can select the paper of the type you are using. Your particular printer software may use a slightly different terminology to 'Media type'.

Choice selection

Look out for 'sustainable forest' labels, some of which state that the paper is 'made entirely from pulp obtained from 100% farmed trees' or similar. This means you are buying an ecologically sound product. If paper is recycled, this will normaly also be highlighted on packaging.

Special quality paper should be stored away from sunlight and extremes of temperature, and any prints you make should be kept in resealable bags to protect them from humidity, sunlight and temperature variations. If you see a label that states that a particular paper is 'Neutrally sized', it means it is neither acidic nor alkaline. This is significant for long-term storage, since papers containing acids degrade and may also damage objects that come into contact with them.

▲ If you want to be environmentally friendly, look for recycling logos, which indicate that the paper you are buying has been produced from reusable sourcc.

MUST KNOW

Paper weights

The gsm that appears after a number on paper packaging indicates the weight of the paper measured in grammes per square metre. In effect, this translates to the thickness of the paper: the larger the number, the heavier or thicker the width of the paper. For good quality photo prints, aim for around 240gsm and above. Any less and the quality may be too thin.

It can be confusing looking through all the different types of paper on the market, so here are a few of the types you may come across:
• **Photo quality glossy film** A bright, white film; good for photos, and report covers. Generally available in A2, A3, A4, Letter and Super A3/B sizes.
• **Inkjet transparencies** Available in A4 and Letter; clear films producing excellent colours for overhead projections and overlays for presentations.
• **Inkjet cards** Bright, white A6 cards; excellent for creating postcards, snapshots, invitations, and digital photos, for example.

Connecting to a printer

For converting your digital image into something tangible that you can show friends, you need to get your image over to a printer.

Transferring images to a printer

There are basically two methods of getting images from a digital camera onto a printer. The simplest method is to use a direct cable connection between camera and printer. While this is very straightforward, the disadvantage is that only certain printers have the special socket which allows the direct connection to be made. The most obvious devices are the portable photo printers mentioned on page 105.

The other (and by far the most widely used) method for printing an image is to download it onto a computer, and then use whatever printer is linked to the computer. This is a much more flexible approach. You can then make prints of your images at any time.

Similarly, the computer to printer connection is the only means of printing an image that has been received via e-mail or on disk. If your printer is not of sufficiently high quality for glossy photographic prints, then take your images on a CD to a photographic shop and pay for them to be printed out on their professional printer. This is expensive, but guarantees good results.

MUST KNOW

Connections

As is the case with so many aspects of digital photography, it is important to ensure that the equipment you use for printing out images Is compatible with your camera. The connection ports on printers can vary, so be sure they match those of your camera.

▼ Photo printers produce prints direct from the camera via a connection lead linking the two devices.

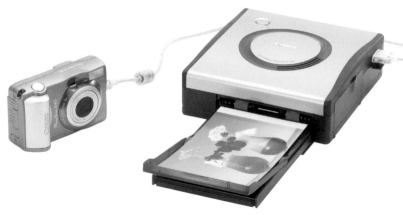

Printer software

When you buy a new printer, you have to make sure it can communicate with your computer. Some operating systems will be able to do so without any further software, but usually you will need to install the manufacturer's own drivers.

Printer drivers

When a new printer is installed, it must be able to find the correct software on the computer in order for it to work properly; this is known as the 'driver' and controls how documents from your computer print out. The drivers for many printers come as a standard feature on some operating systems, whereas others need to be specially installed. New printers will come with the drivers supplied on CD. These are easy to install, since the disk will auto-start when it is inserted into a computer. The set up procedure is simply a matter of following the instructions on the screen. If the disk is missing – maybe the printer is second-hand or the original has been lost – a search on the internet will usually prove fruitful. Personally, I use Google (www.google.com) as my search engine. If you enter the name of the printer together with the words 'free download' and 'driver' in the Search field, it will nearly always result in what you need in order to get your printer 'talking' to your computer.

▲ The printer driver will ensure that the correct messages are sent from the computer to the printer, in the form of electrically conveyed digital information.

▶ When you print an image out in Paint Shop Pro, this is the dialog box you will see as you click the 'Print' icon. It allows you to specify the number of copies you want, as well as the size, orientation and position of the image.

▶ Computer overview

So many of us use computers these days that they have become a feature of just about every household and office. Nevertheless, it is worth taking a quick look at which models are likely to be the most suitable for your needs.

Hardware issues

If you already have a home computer, it will probably be entirely adequate for your purposes. Processor speeds are usually above 2GHz, but you will not need one this fast unless you do a lot of image processing. Anything around 400MHz upwards will do the job perfectly well.

Memory sizes

Far more important than processor speed is the amount of RAM you have. This is the solid state memory the computer uses when doing any processor intensive operations. Start with a minimum of 256MB, and fit more if your machine will accept it (memory is relatively inexpensive).

Technical terms
The 'processor' is what determines the speed of your computer – the larger the number, the faster it will go. 'RAM' is 'Random Access Memory'; again, the more you have, the faster you can work.

▼ Compaq also produce some excellent desktop computers, such as the Presario 8000.

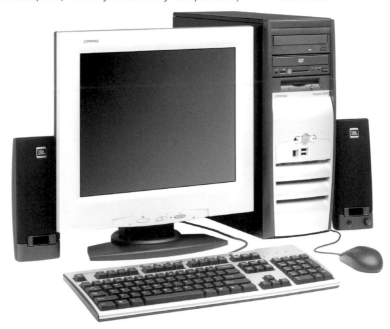

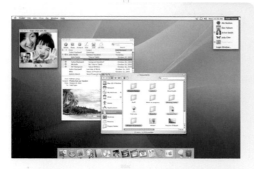

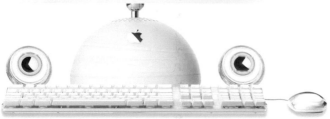

◀ The latest iMac models from Apple Macintosh are styled very differently from traditional box-shaped computers. They come with flat screens which can be positioned at just about any angle – whatever is most comfortable for the user.

Types of computers

There are two main types of computer in use today – PCs, which run Microsoft Windows or Linux operating systems, and Apple Macintoshes, which use their own dedicated system, known as Mac OS. The typical home computer is known as a 'desk station', whereas the smaller, briefcase-sized units are known as laptops or notebook computers. There are a variety of even smaller devices available, and as time goes by these will undoubtedly become more and more popular.

Portable computers

If you travel frequently with your camera, a laptop may be worth considering. Otherwise, there are many reasons why a desk station computer is likely to be your best choice. Faster computers are being brought out almost every day. This means that, sooner or later, your machine will need upgrading. Fortunately, this is relatively easy to do. Components that need changing are simply removed (by yourself or an engineer) and new ones fitted.

MUST KNOW

A hard bargain
The hard drive (disk) stores all your work on it and should be at least 10GB. A second drive can be used as an in-situ back-up drive to store all your important images.

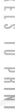

▶ Operating systems

An operating system is the software that a computer uses in order to function. It supervises the hardware and co-ordinates all the various programs that you run. A good, stable and fast operating system can make a computer a pleasure to use.

Computer platforms

By far the most common forms of operating systems – known as 'platforms' – are the various Microsoft Windows variants. These include Microsoft Windows 95, 98, ME, 2000 and XP. Some of these are available in different formats, such as 'Home Edition' and 'Pro'. Apple uses its own operating system for Macs known as 'OS X', which stands for 'Operating System', where the 'X' represents the version number. Unless you are an advanced user, stick with a current version. In any case, I always recommend that people stay away from the very latest releases, as it is much better to let the experts find out about bugs and incompatibilities in a new system rather then doing it yourself the hard way!

There is a third category of operating system, which covers all the less well-known products, such as Linux. This is a derivative of the old 'user-unfriendly' UNIX system.

▲ Apple Macs are used extensively in the publishing industry and by graphic designers. OS X is the latest generation platform for running these computers.

◀ The vast majority of personal computers across the globe run on one of the many MS Windows variants. Windows XP is the latest generation of operating system to come from the Microsoft Corporation.

WATCH OUT!

Moving platform
New programs will come out that demand a specific version of an operating system to run it. Check with the supplier that other programs will also be compatible.

Backing-up your work

An important (but often overlooked) issue when working with computers is to make sure that you have back-ups of your work, not just on your hard drive but also on a CD or DVD.

Auto saves

I have my word processor configured to save automatically every ten minutes (you can do this with most programs), but in the event of a power failure the file may become corrupted, in which case you will be glad you backed it up. Additionally, if you experience a hard disk drive failure, you will be lucky to resurrect anything off it, so it is best to get into the habit of backing up.

Burning issues

A CD writer is a good investment; in fact, most new computers now come with one built in. Take the time and trouble to make CD copies of all your work, and then store them somewhere where they cannot get damaged. The process of writing a CD is known as 'burning'. Old office safes can be bought cheaply, and in the event of a fire or a break-in, your work will not be lost.

▼ Keep your back-up disks in a secure place where they will not be damaged.

Keeping your computer virus-free

It is a sad fact that there are a lot of malicious people who derive pleasure from creating ever more sophisticated ways of interfering with your computer from afar. The methods they use can be grouped together under the term 'viruses'.

By far the most common way of viruses making their way onto your computer is through infected e-mail attachments. The amount of damage a virus can do depends on its type. Here are a few guidelines to follow if you want to keep your machine clean and unaffected.

Firewalls

One of the best ways to help reduce the ingress of unwanted programs onto your computer is to use a 'firewall'. This is a method used by a special software program to block the passage

▼ Firewalls can intercept and block any unwanted programs, preventing them from causing harm to your computer.

of information to and from your computer. Each time another program attempts to access your machine from the internet, the firewall intercepts it, and will only let it through if you have set the program to do so. Microsoft Windows XP has its own version of a firewall already in place, but if you are running an earlier version, consider installing one. Many are available free on the internet – Zone Labs at www.zonelabs.com, for instance, has a free program called 'ZoneAlarm', which works very well.

File attachments

Never open any attachments with the file extensions 'scr', 'exe', or 'pif'. If you are in any doubt about an attached file, do not open it. However, before you delete it, do an internet search to see if there is any information available about it, just in case it is from someone you know.

Anti-virus programs

There are a huge number of anti-virus programs available. Personally, I run two at once. One runs as soon as the operating system starts up; it then stays in place until the machine is shut down again. I use the second program sporadically to check whether the first has missed anything.

No matter which software you use, it will only be as good as the definition files it has to work from. These files are special lists used by the anti-virus programs, which tell them what are the latest viruses and how they can be recognized. They are generally free to download, and since new viruses are coming out all the time, you can never update them often enough. Once a week is the absolute minimum if you want to stay virus-free. The best attitude to take is one of extreme caution – be complacent and your machine will become infected at some time!

▲ Viruses spell danger for big business, as well as for the individual computer user.

▶ Monitors & pixels

When using a desk station computer, it is important that
the monitor is up to the job. A poor quality screen will make
all your images appear dull and lifeless, and the colours
will almost certainly be distorted as well.

General issues

Make sure that the monitor screen is large
enough for you to work on in comfort, especially
if you are doing lots of image manipulation.
Monitors of superb quality have become more
affordable, but good second-hand monitors can
also be bought through newspaper adverts or
from specialist dealers.

Staring at a screen all day can adversely
affect your eyesight. Take regular breaks and re-
adjust your eyes by looking at a distant object
every so often. You will only ever have one pair
of eyes, so look after them!

How the monitor works

A desktop monitor works in much the same way
as the screen in a traditional television set.
However, monitors are available with many
different resolutions. You can usually change the

PIXELS TO PRINT

◀ Consider purchasing
a large, flat-screen LCD
(liquid crystal display)
monitor if you are going
to work on lots of images
on a regular basis.

◀ You can easily change the screen resolution of your monitor so that your images can be viewed at their absolute best.

▲ If you want to change or check your screen settings on a Windows-based machine, simply right-click the mouse over the desktop. When the screen appears, click the settings tab at top right, which will produce the screen shown. Select 'True Colour' – if your hardware can support it, of course.

number of pixels used to make up the screen area to suit your situation as well. The higher the number of pixels used the better, although the colour setting will also influence the image quality greatly. The setting known as '16 bit High Colour' will give you good results, but '32 bit True Colour' is much better overall.

The video card controls the quality of what you see on your monitor. It might be worth investing in a better video card, so you can view your images in all their glory. My monitor gives the best results at 800 x 600 pixels on True Colour.

Monitors have pixels, too

As with digital cameras, monitors compose their pictures from many thousands of pixels, each of which is controlled for colour and brightness. Controlling a grid of pixels is called 'bit mapping' and digital images are called bit maps. The higher the number of pixels, the better the resolution – and the overall picture quality. When an image is enlarged too much, it becomes possible to see the individual pixels, an undesirable effect which is known as 'pixelation'.

Scanning & re-touching old images

Image editing is great for digital pictures, but it can also be used to great effect with old or damaged prints. The print first needs to be digitized. Of course, you could take a photo, but far easier would be to scan the print and save it digitally.

Flatbed scanners

If you want to make a copy of a flat image, a scanner is likely to be your best option. There are two basic types of scanners – professional and domestic. The former are used mainly by the publishing industry and produce super-high quality images. They are ideal for scanning film slides, as well as for reproducing photographs at very high resolutions.

When flatbed scanners first came onto the domestic marketplace, the best models were very expensive and out of reach for most people. To cater for the budget end of the market, a variety of hand scanners were manufactured. Unfortunately, most of them performed to a somewhat mediocre standard. In more recent years, flatbed models have fallen in price to such an extent that really good ones can be obtained fairly reasonably.

One of the other benefits of advances in scanning technology is that they are much easier to use than their predecessors. Nowadays, all you have to do is plug them in via a USB port, load up the software CD, put the item you

> **WATCH OUT!**
>
> **Film or print?**
> If you need to scan film transparencies, your scanner will need an accessory known as a 'transparency hood'. Most scanners do not come with this item as standard.

▼ This is an economical flatbed scanner, suitable for home or office use. While it has very easy to use controls, it can scan at 1,200 x 2,400dpi with a 48-bit colour depth.

want to scan in place and press the 'Scan' button. The image is recorded and transferred into your graphics program, which is then automatically started for you.

When you have made a scan, the first thing to do is to resize the image using your graphics program, because it will almost certainly be at too large a size to work with. It might be worth making a copy at a reasonably high resolution and size (possibly for publication use), and a further copy at

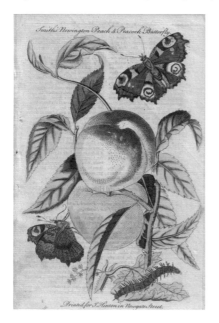

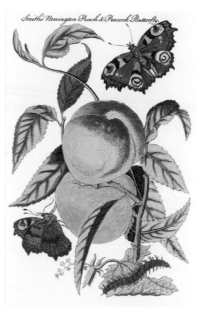

a much lower size for general use. To illustrate the type of things you can do by combining your scanner and your graphics package, here are two images (see above), which I recently scanned and re-touched.

On the left is an original page from a magazine dated 1754 entitled *Smith's Newington Peach & Peacock Butterfly*. You can see how the text from the facing page has stained it, and how there are various other defects on the page. On the right is the same image after I used Paint Shop Pro to re-touch it. It is worth noting that this was not a quick process, but it shows what can be done with patience and care.

▲ With a little time and effort, you can sharpen up tired-looking prints and even change the background colour to make the page stand out.

Cleaning up

To examine in more detail how the re-touching was performed, let us take a look at a specific part of the *Smith's Newington Peach & Peacock Butterfly* image.

Once again the original is on the left, and we can see how badly damaged it is. In the picture above I have zoomed in by a magnification of x15 using Paint Shop Pro on the end of the butterfly's wing. See how the image becomes a series of individual pixels at this level of magnification. It is then simply a case of going around and changing the pixel colours to those that you choose.

This is done using exactly the same process as was applied earlier to re-touch the motorcycle number plate (see page 89) – that is, by using the paintbrush tool and the colour palette. If you were to do this to an image as large as this one by modifying individual pixels, the task would take forever. The trick is to use the control palette to select a large paintbrush for all the broad areas of colour, and then to keep zooming in further using ever smaller paintbrushes until you are happy with the overall result.

▲ The original detail from the print is on the left, with the final retouched version on the right.

▼ Zoom in to a detail on an image so that you can select pixels to re-colour them individually.

There is much debate as to which is the best graphics package to use for the amateur. As with so many things in life, however, there is no single answer. The full version of Adobe Photoshop is the program most favoured by the professional. For the hobbyist user, Jasc Paint Shop Pro or Adobe Photoshop Elements are more than sufficient, unless you are after significantly more advanced features.

Other graphics programs

There are lots of other graphics programs in the marketplace and many of these are aimed at the domestic user. You may well find that they provide all the functionality you need without the complexity or expense of the larger packages. If you have access to broadband internet, then it is always worth keeping an eye on the official websites of companies such as Adobe and Jasc, since they often have time-limited trial downloads available for free. Try out as many different programs as you can and choose the one that best fits your needs.

▼ This image was opened up using Adobe Photoshop, the package favoured by professional photographers.

Displaying images

As well as viewing your images on your computer in thumbnail, real-size or full screen formats, it is also possible to look at them on other media, including television screens, projection screens or handheld devices.

Using the video out facility on your television

Apart from those models at the budget end of the market, most digital cameras have some form of small LCD screen on which it is possible to view your pictures. However, if you are away from your computer or have a group of people that you would like to share them with, it can be difficult trying to display them to everyone at the same time. An excellent solution to this is available if your camera has a video-out port. This will allow you to connect it to a television set through the video-in terminals. Make sure you have the correct cable – it is usually supplied with the camera. Simply plug it in and away you go!

Personally, I find this is an excellent way of reviewing my day's work if I am travelling without a laptop. How many of us want to carry around a computer when we are on holiday? There are other useful things you can do by connecting

MUST KNOW

Has its uses?
Before buying a photoviewer, consider whether you will make enough use of it. Would you prefer to create photo CDs rather than present them on the television?

◄ The SanDisk Photo Viewer is ideal for domestic presentations. Using the remote, you can view your photos on your television. The remote control also allows you to rotate and zoom into your photos.

TV slideshows

As well as using your camera to produce a slideshow, photoviewers
are great for any friend or family member who does not own a computer.
By linking the photoviewer into your video recorder (VCR), you can record
the photos onto a video tape and share it with them in a slideshow mode.
In a slideshow setting, photos are changed every few seconds.

your camera to a television. While it works well
as a giant view screen, so that your family and
friends can see your existing photographs, they
can also watch live images of new ones being
taken. Alternatively, you can set up a video
recorder and capture a whole sequence to
show off later.

While a television offers an excellent way of
presenting images to a small group of family and
friends, it is not a very satisfactory method for
presenting them to larger groups. A public
display device, such as a digital projector or
some sort of a cinema screen, would be ideal.
For medium-sized groups of up to a hundred or
so, a multimedia image projector is ideal.

For reaching larger congregations, a public
performance display is really the only answer.
With a suitably positioned system, it is possible
for several thousand people to see the screen.
Such equipment is very expensive, however,
and strictly for professional organizations.

▲ If you have to present your images to a
fairly large group of people – in a business
seminar, for example – then a projector and
screen will probably be a more effective
means of display than a television set.

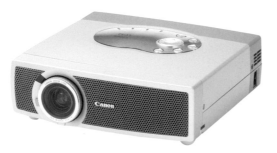

◀ The Canon LV-S2
Multimedia Projector is ideal
for public presentations, and
for a variety of leisure or
business purposes.

PIXELS TO PRINT

125

Portable image storage and viewing devices

If you take a lot of photographs and like to travel light, there are several portable items of equipment on the market to answer your needs. For example, there are handheld image storage and viewing devices available that can hold vast numbers of digital photographs – in some cases, between as many as 10,000 and 30,000!

These units can read most card formats and have sophisticated file management systems, which can store images in folders. In addition, individual files can be renamed, copied, moved around or deleted. There are also features that appeal to professional users, such as the fact that these units are able to handle images in RAW format of up to 18MB each. It is also possible to view histograms and other information, as well as to upload images from hard disk drives onto the handheld units, or to make hard copies of images by connecting directly to a printer. All in all, they are extremely useful devices.

Keeping up with the trends

The trend with portable devices is to go even further than simply showing images. Many allow you to combine digital photos, videos and MP3 music in the same device. This means you can create slideshows with special transitions and accompanying music, and play them back anywhere.

▼ CDs or DVDs may offer a portable means of storing images, but many handheld devices can hold just as many images and also offer the facility of viewing them. Additionally, handheld devices are generally far easier to carry.

PIXELS TO PRINT

126

◄ The Nixvue Vista is available in 10, 20 or 30GB capacities, and runs off lithium-ion batteries. It has an LCD screen to review your images, or it can be connected to a television set or computer for larger displays. This device is not a cheap option, but for those with a serious need for storage and viewing capabilities on the move, it represents an ideal solution.

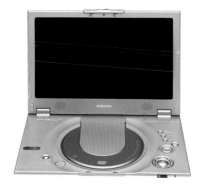

▲ The Samsung L100 DVD player is a portable unit with a screen that is similar in size to that of a laptop. However, it is also about the same price as a laptop, so it will mostly appeal only to those enthusiasts with the deepest pockets!

Another way to view images while on the move is with a portable DVD player or a laptop computer. Since these tend to be about the same size and weight, many people cannot see the sense in paying out for a DVD player when a laptop can do so much more. There are also many multimedia players on the market. These tend to have LCD screens of around 85mm (3in) in size and can play MP3 files as well as display images. Depending on the make and model, you can connect to a printer or a television. If you are considering purchasing one of these, take some time to review what each version offers – the storage capability, the types of memory cards they can accept, whether they can deal with your camera's image formats, especially if it has a video mode, and so on.

E-mailing digital photos

Most of us have access to e-mail these days. In fact, one of the most popular ways of sharing digital photos between family and friends is by sending them by e-mail. You can even e-mail images to and from mobile phones (see page 130).

E-mailing issues

To send a digital photograph by e-mail is simplicity itself. However, there are a few things to watch out for. Firstly, make sure that you have shrunk the image down to a sensible size. Even if you have broadband internet access, the recipient may not, and a 15MB file on a dial-up connection will make you very unpopular indeed. A good rule of thumb is to keep the images down below 100KB; if you have lots of images to transmit, it is much better to send lots of messages with small attachments rather than one message with a massive attachment. If you want to send large files, it is good etiquette to contact the intended recipient first to see

▼ Old technology may not be able to cope with sending and receiving large e-mail attachments, so make sure your computer hardware is up-to-date.

whether they can receive them easily. It may be better to send a CD through the post rather than to annoy someone with a large file attachment.

Blocked out

Another thing to bear in mind is to check whether your intended recipient's e-mail system will actually allow attachments through. If you are sending an e-mail to a company, many have become so security conscious that attachments are viewed with great suspicion and are often blocked out – that is, returned unsent.

Sending the image

To send an image is very easy. Write your e-mail message in the usual manner, and then look for an 'Attach' button. Click this and you will be presented with a file browser, where you can look for the image file to send. Click on it, click 'OK' and the file is attached to your message. Effectively, that is all there is to it. When the e-mail arrives at its destination, it can be opened by the recipient for viewing and saving if necessary.

Use an appropriate format

It is also important to remember that not everyone has their own imaging software packages, so when you send an image file by e-mail, make sure you choose the most appropriate format. If you send someone a Photoshop (.psd) or a Paintshop (.psp) file, they may well not be able to open it. JPEG and GIF files are universally accepted these days. These formats are also efficient in terms of quality and size, so they are good choices for e-mail attachments. The one problem with attachments is that you can also attach EXE (.exe) files, which is how viruses are spread. Many people have stopped opening them and firewalls or filters are available to block them (see pages 116–17).

▲ Sharing images has never been easier, thanks to the miracle of e-mail – all it takes is a click of a button. You can send your friends and family holiday snaps from anywhere in the world.

▶ Sending images by camera phone

Camera phones are becoming more popular. These devices are handy for commercial purposes; for instance, estate agents, car trader magazine staff and art dealers can all send images back to the office from wherever they are.

It's good to snap

If you are sending a camera phone image to another camera phone, the recipient must also be on a network that can communicate with your own. If there is a problem, you will get an error message back telling you why. A link to the photos can be sent by e-mail to anyone with an e-mail address. Recipients are sent a text message explaining how to view your photos over the internet. These websites are part of the service provided by the phone companies. Your images are kept in your own personal photo album, which is protected by a password so that you can decide who gets access to your pictures. Camera phones and other devices that support this service let you include still images, video images and sounds together with words via MMS (multimedia message service).

▲▼ The Nokia 7600 Imaging Phone seen from the front [above] and rear [below]. Its futuristic looks represent a move away from more conventionally styled mobile phones. It is packed with powerful features, including a camera with video recording, a multimedia player, Bluetooth wireless communication and a high quality display.

MUST KNOW

Endless possibilities

As well as sending images from 'on location' to other camera phones or e-mail recipients, photos can also be used as wallpaper or as a screen saver to personalize your phone. You can even add pictures of people to their listings in your phone book. This means you can actually see – or let others see – who is calling, with their individualized photo caller identification.

Sending images to websites

If you are creating your own website or want to post your images onto someone else's, there are three main ways to transfer your images to the host location.

The three methods are:
- By using a file transfer program, such as FTP (this stands for 'file transfer protocol')
- By using the 'Upload' facility found on some websites
- By e-mail. This only works if you are sending them to someone else to post for you.

The best way to send large files to a website is via an FTP package. There are many different versions available, some of which can be downloaded for free from the internet. Using such a program, you can move large files from your computer across the internet to a folder at the host location. You will need to know certain technical information about the host machine. This includes the host's web address, as well as your UserID and password for that machine.

◄ WS_FTP is a good example of a file transfer program. With it you can move large files from your computer to remote locations. The transfer speed will, of course, still be constrained by your internet connection.

PIXELS TO PRINT

131

▶ Web & photo logs

You may come across on-line web diaries on the internet. These can be updated instantly and need little technical knowledge. Image-based pages are now just as common.

These web diaries have evolved into several different forms: predominantly text-based ones are known as web logs or 'blogs'; when the main content in a web diary is image based, this is known as a 'photoblog'. While these are the two most popular forms, there is a third version in which content is received from mobile phones known as a 'moblog'. The basic concept of a blog is that it is a web page or site to which the owner regularly adds content. It acts as a kind of living thing that continually grows; the updates may occur as often as several times a day or far less frequently, depending on the site owner.

One of the beauties of blogs is that there is no single format. You can create your own, and style it and fill it in any way you want. If you have a particular hobby, you may use content that will appeal to others with similar interests.

▼ In the past, the only form of a diary or log was one that was written down. Since the creation of 'blogs', updating such information on a website has never been easier.

Peer-to-peer file sharing

Sharing images straight from your computer via the internet sounds a risky proposition, but by using various softwares, other people can access your files safely and securely.

Spread your message

If you have images that you would like to share with lots of other people, one of the best ways to reach large numbers is to use something called peer-to-peer file sharing (sometimes known as 'P2P'). This is where you give others access to certain folders on your computer. Obviously, just who gets the access depends on how you set it up. It can be completely public or it can be strictly for private access only. Either way, peer-to-peer sharing does not mean people get to see inside all your computer's files – you decide what they can and cannot access. One of the other useful features of file sharing is that you can access your own files through any internet-enabled machine, even if you are on the other side of the world.

Peer-to-peer file sharing had a certain amount of bad press in the late 1990s and early 2000s due to all the fuss surrounding the use of Napster. This was a piece of software that was used for sharing music files. Unfortunately, this fell foul of copyright laws, and major law suits resulted. However, the basic principle of sharing files has a lot of merit, but only when there are no questions over their ownership!

Find out more about peer-to-peer file sharing at the following sites:
www.openp2p.com/
www.cio.com/research/knowledge/edit/
p2p_content.html

▲ You can access your own computer through P2P from anywhere in the world.

WATCH OUT!

Up to you
With P2P, you give the permission as to who can download files. Be careful who you share your private files with – you never know where they might end up...

133

Home entertainment networks

The ability to access images from your computer through your television set – without first going to your computer and copying photos onto a CD or DVD – is today a reality.

If you use your camera frequently, you will soon build up an enormous archive of image files. If these are stored on your computer, then under normal circumstances direct access to these files will be limited to the number of people who can crowd around your monitor. It may well be that you work on a computer during the day, and the last thing you want to do when you get home is to have to spend your free time sitting in front of a monitor as well.

If this is the case, then a home entertainment network is for you. This device will allow you to access your computer from around your home. With such a system you can, for instance, view your images on your television set. If you have a large screen model, then, should you wish to, you will be able to show them off to large groups of family and friends with ease.

◀ Digital entertainment systems allow you to display image files from your computer's hard drive on a television set in a different room of the house.

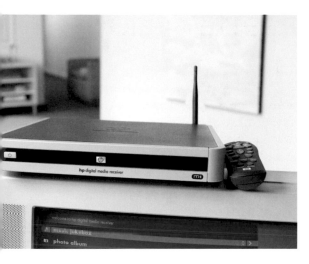

◄ Wireless home entertainment networks are the easiest systems to install because there are no wires to run through the house. This means not having to lift floorboards or drill holes in the walls to hide the cables, which is a distinct advantage!

Spreading it around

If you have a modern home entertainment system set up, it should be capable of automatically recognizing new components as they are added into it. As more and more appliances are being produced that have Wi-Fi (wireless) capability, so the possibilities of these domestic networks are also increasing. It is not only images that can be transferred around the home. Music files can also be accessed from your computer and played on surround sound systems or other advanced audio devices.

If you have a Bluetooth enabled system, then you can upload different music files to your portable device before you leave the house each morning.

▲ Home entertainment networks enable large families or groups of people to view holiday pictures in the comfort of the living room, rather than having to crowd around the computer.

MUST KNOW

Wireless connections in the home

To create a home network, you need a router, which connects to the cable modem or device you use to access the internet, ideally with a wireless access point. Network adapters are cards for a desktop or notebook computer. Some are wireless and others have connectors for Ethernet cables. Many high-end computers and even handheld devices have Wi-Fi built in.

Digital frames

Most of us will have at least one framed photograph in our home of friends or family. However, have you ever thought about a framed picture that changes from time to time?

Seeing is believing

One of the latest ways of displaying your images is in a digital frame. These look similar to traditional picture frames, but instead of having fixed illustrations, they have an electronic screen on which any compatible digital image can be displayed. JPEG files can be shown by all digital frames, but some will accept other formats.

There are three main ways in which images can be transferred from their storage location onto a digital frame. Firstly, the frame can be directly linked to a computer by a network cable. This allows images to be moved to it from the hard disk drive or even straight from the internet.

The second route is to insert a memory card into a special reader slot on the digital frame and then download the images. Some frames are limited to a single card format – CompactFlash, SmartMedia and Memory Sticks being the most popular, although others can accept several different types. If you buy a digital frame, it is important to make sure that it will read the same cards as you normally use.

A third method of connecting a digital frame to a source of images is through a wireless system. The two most common systems are Bluetooth links or wireless area networks.

▼ Once images have been transferred to a digital frame, it can be positioned where you like, depending on whether it is a battery or mains powered version. If it is the former, then you can even take it with you in the field and use it as a portable image viewer.

PIXELS TO PRINT

Protecting your electrical equipment

No matter how careful we are with our virus-checking, our backing-up or general computer maintenance, external forces can conspire to harm our digital data.

Spikes can hurt!

Perhaps this is a good time to mention other back-up issues. Always make sure that your computer is powered through a socket with a 'spike protection' device. These are available as multi-socket adapters and some even have telephone line protection built in as well. The reason for the existence of these protection devices is that if there is a lightning strike in the vicinity, your computer could end up as a smouldering pile of electrical wreckage.

Another useful device is the UPS – uninterruptible power supply. This is a vital piece of equipment if you work in any area where power cuts are possible (which, in reality, means anywhere on the planet!). Basically, the UPS is a large battery coupled with an inverter; if the mains power fails, a sensor in the UPS takes over and keeps the computer powered up for a given period, typically around 20–30 minutes.

▼ If your computer experiences a power cut, you can lose work. If it experiences a power surge, such as from a lightning strike, you can lose the entire machine. An uninterruptible power supply could save you a lot of time and trouble!

▲ Lightning can strike anywhere – and its effect on computers can be devastating.

want to know more?

Take it to the next level...

Go to...
▶ **Downloading your photos** – page 22
▶ **Images and pixels** – page 30
▶ **Where to buy gear** – pages 42–3

Other sources
▶ **Visit electrical stores regularly**
 prices fluctuate and bargains can be had!
▶ **Consumables' websites**
 compare the cheapest on the internet
▶ **Technical magazines**
 will provide details of the latest products
▶ **Libraries**
 try your local library for technical books
▶ **Computer maintenance**
 ask your dealer about the latest gizmos

public

image

Digital photography is a great medium for lots of different purposes: holiday snaps; pictures of the kids; photos of objects to sell through on-line auctions; action at sporting events; subjects from nature; and even night shots. In this chapter we discuss all these areas, as well as commercial photography and how to create your own website.

▶ Taking holiday snaps

Even if the photos we take on holiday do not turn out as vibrant as the scenes we remember, the digital age allows us to restore that vibrancy thanks to various image enhancements.

On location

Before the days of the digital camera, on returning from holiday we would put our films in for processing, wait at least a few days, and then our eager anticipation would turn to disappointment as we saw the results of our endeavours.

◀ Taking pictures of bright sunny places often results in images in which the shadows look very dark, and the colours are very muted. Fortunately, in the case of digital images, we can do something about it…

◀ This version of the image has been retouched using the automatic photo enhance feature. However, while it has improved some of the colours, overall it has resulted in a harsh image with a loss of detail in the dark areas.

◀ In this version, I enhanced the image manually by using the Brightness/Contrast facility to brighten the whole picture, then Automatic Saturation Enhancement followed by Automatic Colour Balance.

Beach scenes can often raise lighting problems, as can be seen opposite on page 140. The original has lots of dark shadows and muted colours because the camera has tried to compensate for the strong sunlight. Many graphics programs have an 'Enhance Photo' facility, which applies a series of enhancement operations with one click. In Paint Shop Pro this is called 'One Step Photo Fix'; in Photoshop Elements, under the 'Enhance' menu, simply click on 'Quick Fix'.

If the result does not produce the desired effect, then try the manual approach by using Brightness/Contrast, then Saturation and finally Colour adjustment. All three of these operations allow you to tinker with the settings, so it is a good idea to play around with them (using a spare copy and not the original!), until you feel you have achieved the right combination. When you are happy with the result, you can use the sharpen tool to add crispness to your image. Always do this last, or else you will magnify the sharpening lines, which may ruin all your hard work.

▲ This image shows the same problem as in the pictures of the beach opposite. The sign has bounced so much light back at the camera that the landscape behind it has gone very dark.

▲ In this version of the image it has been possible to bring out some of the detail and colours of the background scenery. The sign itself, however, prevented me from going much further, because it was becoming too light.

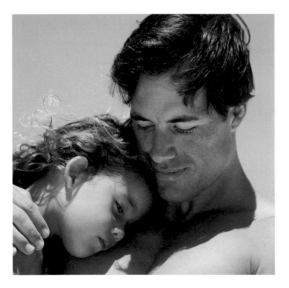

◄ Some holiday snaps will not need any special manipulation – they speak volumes just as they are.

On reflection

One of the big problems with taking photographs of holiday landscapes is that the difference in light levels between the sky and the ground can cause all sorts of problems. The main issue is that you can lose the blues from the sky, making the picture appear very white and bland.

Shooting over water can exacerbate this problem, due to the reflections. Many digital cameras have an in-built bias towards the bottom of the picture to offset the effect of the sky. As soon as you get bright reflections off the water, however, the offset compensation is lost. One way around this is to take a series of photos at different aperture settings (the size that the lens opens to). Later on, when you get home and download your pictures onto your computer, you can then use your graphics package to cut the best sky out of one image and put it over the best ground from another. Yes, it is cheating, but you can achieve really good results with a bit of creative endeavour!

> **WATCH OUT!**
>
> **Filtering through**
> In the digital world, it is often easier and better to achieve an effect digitally than with a filter. Although filters seem tempting, they may not live up to their promises.

▼ This photograph of a lake in a Queensland forest suffers from a sky that is too white and scenery that is too dark. Most of this has been caused by the sky's reflection in the water, which has quite badly skewed the camera's light level calculations.

There are also a vast number of filters you can buy to help you take pictures without bleached sky or loss of detail. Some are more useful than others. Polarizers, for instance, are used to deepen blue skies in landscape photographs. They can also work wonders in reducing reflections when shooting through glass or water at an angle, as is the case with the examples on these pages. Neutral density filters are like sunglasses for your camera. The amount of light allowed in is reduced, but without changing the colour. Neutral density filters are often used when shooting in bright light to allow for a larger aperture and so a smaller depth of field. As with most pieces of equipment, check that you really need them before buying, as they are not cheap.

▲ Once again, reflections have resulted in a loss of detail in the shadows on these fishing boats.

MUST KNOW

Try, try again

If camera memory is no object, then take as many shots as you can of a favourite view. The light may change subtly at any time, giving you the perfect picture!

▶ Portraits

A traditional portrait is of a person sitting looking straight at the camera – in my opinion, far too boring. I like to get them to use hand gestures or else add a few props around them.

Setting up the shot

You need to be careful in your choice of setting, however. If it has too many features, for instance, you can lose the main purpose of the shot. Getting the lighting right is of paramount importance – too little, and your shot will be worthless, too much and you will end up with a bleached face.

Look for strong lines in the background, as these can ruin the effect of your portrait. Look especially for vertical objects rising out of the top of the head. Trees, the edges of buildings, window frames and all manner of other structures can create composition difficulties.

Hands-on

Most people feel nervous in front of a camera. It is entirely normal to feel this way, but it can be hard work trying to get a subject to relax, especially if you are short of time for the shot.

MUST KNOW

Posing around
If you find an arrangement that works, take lots of shots with a similar set-up, but vary small details each time. This will give you greater choice.

▼ To get your subject into the right frame of mind, get them to go through a range of hand positions. No single pose will work for everyone, so take lots of shots and see which one works the best.

One of the worst contributors to this camera awkwardness is other people watching. Not only will the subject be nervous, but they will feel far more self-conscious, as well. If you can, it is best to clear the area, so you are left alone with your subject. If your subject wants a friend, partner or family member to remain while you are shooting, get the other person to either sit out of your subject's view or to sit immediately behind you, depending on the situation. If it is a sibling who has come along to pull faces, it can help or hinder, so you will have to respond quickly and calmly. If they find it really amusing to distract your subject, try turning the camera on them for a while – that often quietens them down!

It is important that you also project a feeling of confidence. If your subject thinks that you know what you are doing and that you are going to produce good results, it is a great help in putting them at ease. One of the ways to do this is to show them the particular pose you want by mimicking it yourself. If your subject knows what you want, they will often relax a lot more.

▲ Children are often the least self-conscious of all and will pose for a photo wherever they are. However, this is not always the case, and of course, all children are different!

◀ When you take portraits outdoors, bright sunlight can reflect off the face, which results in the camera miscalculating the light level settings. In this shot, the skin is bleached, the pink ice-cream appears white and most of the detail in the background is lost into a large, black shadow.

▶ Taking pictures of children

Photographing children in traditional poses is generally a nightmarish prospect! Taking pictures of kids at play, on the other hand, is a much easier – and pleasurable – proposition.

Catch the moment

When it comes to taking photographs of young children, there is a whole range of issues to take into account. For a start, kids get bored very quickly, so you cannot spend ages setting up the shots. The best thing is to be ready with the camera – kids do unexpected things at unexpected times, and you are likely to have very little time to respond.

While large, complicated cameras will give you the best results in terms of quality, they can be very inconvenient to carry around, especially if you have to carry the child as well! The pictures shown on this page are of my daughter, Carina. Since I had to carry her, as well as any equipment, I used a smaller, aim-and-click camera so I was not hampered with camera cases and expensive lenses while chasing her

▲ Here, we are playing 'hide behind the tree'. Each time Carina jumped into view, she had a huge smile on her face, resulting in a series of wonderful photographs.

◀ If you can make a game out of posing for the camera, you have a much better chance of getting the subject's attention. To get this shot, I was blowing raspberries at Carina, and she was copying me, smiling every time she did so.

around the playground. All I had to do was to make a game of taking the picture, choose the right moment to release the shutter and there was my perfectly posed photograph! Had I been using a more professional, expensive camera, I would never have got any of these shots, each of which I treasure immensely.

Digital cameras are ideal to take to family events and celebrations, where they can be unobtrusively left in your pocket or handbag and whipped out when the moment arises. That way, young children are unaware that they may be thrust into the spotlight, with the danger of them turning self-conscious, and will continue just being themselves. These are the best moments to quickly take out your camera and take unposed, natural pictures, which are often far more effective than traditional group photos in which everyone stares at the camera and says 'cheese'!

Above all, though, do not let photography take over your life at these events. Make sure you join in with the events you are recording!

▲ My father on his 84th birthday with his grand-daughter Ana. You cannot pose this sort of thing, so it is best to stay alert.

▼ Children are often much better than adults for producing wonderfully natural smiles, which are easily captured in a photo.

147

▶ Sports & pastimes

If you have a passion for a particular sport or pastime, then what better opportunity to share your memories than in photographs? Motor racing enthusiasts are probably the most challenged photographically – by the problems of speed.

Fast and furious

If you want to photograph fast moving objects, then practice is the best way of achieving good results. The more shots you take, the better you will get at them. Working as a racing car engineer has given me access to many areas that private individuals would never be allowed near. On these pages are a few images taken from the perspective of the pit lane or around the racing circuit.

Some circuits have a Plexiglas safety screen in place on top of the pit wall, so even if you manage to get that close, if you were to try and take a shot through it you would get lots of reflection. Occasionally, however, you may achieve an effective blend of reflection and subject, which you can ascribe to your photographic artistry. Such pictures are often down to pure luck rather than judgement.

MUST KNOW

Fast action
As mentioned on page 77, try using the fast action mode to increase the shutter speed of the camera and thus reduce blurring in the finished image.

▼ It takes a lot of practice to get a fast moving car where you want it on frame. If you want to convey a feeling of speed, it is a good idea to get some empty track in front of the car, not behind it, as here. This just makes the car look slow.

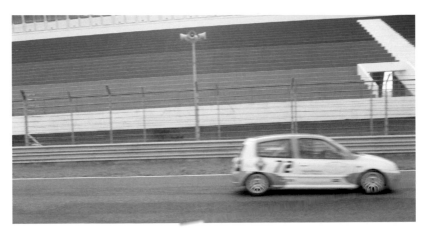

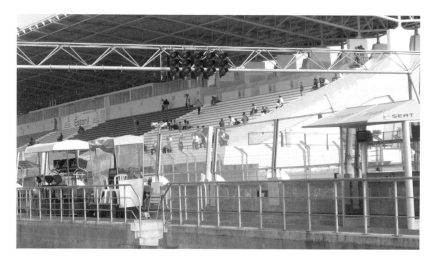

▲ If you want to record the start of a race, plan your day well. Finding a good location at the last minute is likely to leave you in the wrong place at the wrong time, as several thousand other fans will all have had the same idea.

However, even professional photographers, especially those who specialize in motor racing, will often take hundreds of shots which end up being discarded for the one, 'spot on' image. A good example is the speeding car on the track, where practice really does make perfect. With the speeds that some of these racing cars reach, it is not surprising that there is little time for focussing the shot, getting the light correct and composing the photo. Before you know it, the noise has faded into the distance and the track is again bare.

Most beginners will end up with lots of shots of empty track. Usually, this is because digital cameras take some time to acquire a focus point, and the subject has passed by the time the shutter is released. To get around this, it is a good idea to get the camera focussed in on a particular section of track, and then as the car comes into the frame, release the shutter. The more times you have a go, the better the shots.

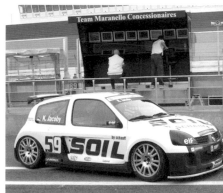

▲ If you find you are not having much luck with shots of cars at high speed on a circuit, the pit lane offers many opportunities for capturing cars moving at a much more sedate pace.

Capturing the action

Many sports and pastimes are just as fast and furious as motor racing, but require different skills with the camera to capture the action and excitement of specific events or fixtures. Next time you go down to the sports centre for a game of squash, cheer on your favourite football team or watch a game of cricket on the village green, make sure you take your digital camera with you. You will find a wealth of opportunities for taking action pictures at every event.

For sporting events particularly, it would be rare for you to be close up to the action. Most digital cameras offer a zoom option to get you closer to the subject, whether it be the cricketer at the crease striking the ball, a footballer at the far side of the pitch sliding in for a tackle or two fencers duelling it out in a competition. Although built-in zooms are fairly modest in comparison with the add-on professional zoom lenses you can buy, they can certainly bring you closer, filling the frame and magnifying the subject matter.

The same problems encountered with motor racing photography are also present at other fast and furious sporting events. The same principle of

▲ The zoom can bring you closer to the action and fills the frame with your subject.

▼ Take some shots where there is a lot of activity going on, for added interest.

▲ You get a real feeling of speed, action and power from this image. The splash from the waves on the boat conveys the speed, with the rowers battling against the force of the sea.

using faster shutter speeds to capture the fast-moving subject is equally relevant. This can look impressive when taking shots of water sports. With a bit of practice, you can capture the drops of water held suspended in the air for a moment in time, giving the picture a sense of movement.

Capturing the people

As with most pastimes, it is the people that really matter at these events, and you can often capture a sense of excitement through the faces and expressions of the people involved, as well as the spectators. Using a tripod to ensure a completely steady shot or getting up high for an unusual overhead shot are all great devices for taking varied pictures of people and events.

▶ Taking good photographs of people playing sports relies on great timing probably more than anything else.

Capturing the flavour

If I were to stick to just taking photographs of speeding cars in an attempt to portray what motor racing is all about to a novice, then I believe I would have failed in getting over the true flavour of the sport.

A day at a racing circuit is not just about high-speed cars – as exciting as they are in their own right. The day is made up of people, events taking place around the circuit unrelated to motor racing, the noises and smells of gasoline and engines. A race day has real atmosphere.

Although it is impossible to capture the noise and smells in a photograph, it is possible to portray a flavour of the day's events. And this involves taking photos of the more unusual, rather than the obvious. Wander around with your camera, away from where most people think the action is taking place. (As mentioned before, though, do not miss what you have come to

▲ All sorts of strange activities go into making up a weekend at a motor racing circuit – some of them creating great photographic opportunities!

▶ Every now and again, you will get lucky and catch someone in a pose that would be perfect for a caption contest. I have no idea what these promotion girls were saying, but the old fisherman's claim of 'It was this big, but it got away' has to be a favourite!

see!). Think about the unusual angle – get down low or else find a position high above everyone. Take a look at what people not involved in the action are doing; find the incongruous scene – Morris dancers at an outdoor rock festival, for example. Look for all the peripheral activities. For example, quad bikes towing racing tyres on a rack along the pit lane at a racing circuit. If you are trying to produce a photographic record of life at a circuit – for a magazine article, for instance – shots like these can be very useful as they give the reader more of a sense of the day; someone looking at images of varied events and activities can really feel the flavour of the experience.

Paint it red

Every weekend, thousands of us indulge in all sorts of sports and leisure activities that involve getting dirty. Others involve putting on uniforms, such as when you take part in a paintballing session. I decided not to risk my camera in the 'killing zone', since it was quite clear it could have been badly damaged. The safety regulations prevented us from removing our masks once out of the relaxation area anyway, and there was no way I could have taken any decent pictures with my mask still on. This is the kind of detail you need to pay attention to if you want to take photographs at many events.

▲ My friend Rob was in his element wearing combats and paintball-shooting people! Getting people to pose in a relaxed and informal manner requires a lot of things – tact and timing being two of the most important.

153

MUST KNOW

Protect your equipment

Whenever you attend events where there are going to be lots of people and therefore lots of pushing and squeezing through crowds, you must ensure that your camera is protected and that you can keep hold of it. The case needs to be fairly robust to withstand the inevitable banging against people and objects. This does not mean it need be a hard, leather case; there are many suitable soft, padded ones around offering good protection. Decide how to carry it. If the case has a strong handle then use it; slotted into a belt as you push up against hundreds of people may not be particularly safe.

▶ Nature photography

The great outdoors is an excellent training ground for the amateur photographer. Not only do the seasons create varied scenes, but wildlife can present you with infinite possibilities for stunning photographs.

The natural world

Taking photographs of wildlife can be incredibly rewarding and incredibly frustrating at the same time. If you do not have a telephoto lens, you will be restricted to subjects that you can get close to. Since digital cameras with macro lenses are very expensive, we are going to discuss what can be achieved with a mid-range compact model.

Getting down close to your subject matter is vital when photographing flora and fauna. Even with a zoom, the photographer needs to position him or herself at the correct angle.

▼ These toadstools are in a reasonably good condition, but will break apart after just a few days, so timing is important.

▼ A decent mid-range digital camera is capable of taking some incredibly detailed photographs if you get everything right. This image of an ivy flower shows what can be achieved. When zoomed-in upon, even the smallest structures of the plant are crystal clear to the eye.

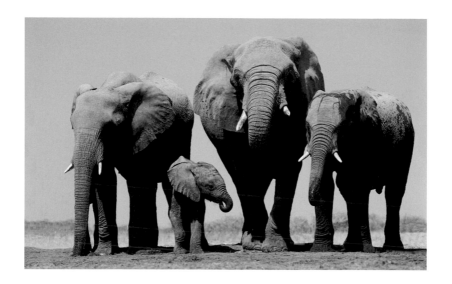

▲ A powerful zoom allows you to photograph potentially dangerous subjects from a safe distance.

Most of the time you need to kneel down – or even lie down on your front – so that you are level with your subject. This makes the subject matter appear intimate and closer. Overhead shots are fine and produce equally satisfying results. In fact, they can sometimes give such an unusual perspective to a subject that the image becomes very striking and stands out even more. Experiment with taking photographs at different angles and different levels in relation to your subject.

Patience is an important skill in nature photography. Fungi are similar to flowers in that they are only at their best for a very short time. If you want to take good photographs of toadstools, for example, you will need to keep an eye on them over a period of a few days. As they start to near maturity, it may even pay to put a box over them to keep rain, frost and

◄ Homing in on your chosen object will blur out the background, even in autofocus mode. You can also knock out unwanted background clutter. It can be a lot quicker to get the shot right in the first place than to spend hours retouching it afterwards with image editing software.

marauding animals from destroying them before you take your shots. The willingness to wait for the right moment will often pay off in the end.

Using the zoom or close-focus to home in on a single subject will make the surrounding scenery look out of focus or blurred. You can experiment with this feature, particularly in the camera's manual rather than automatic mode. The depth of field (that is, the foreground and background) will be more blurred in photos taken with a macro (close-up) feature than those taken with a zoom feature, for instance. However, you can get really close to a subject with a macro shot as opposed to a zoom. It all depends on what you are aiming at.

Butterflies

If you want an ideal subject to hone your skills on, then a suggestion is that you start with butterflies and flowers. The former will test your patience and stalking skills, while the latter will give you a chance to get some experience of sorting out the best angles and compositions.

It is a good idea to learn a little about your subjects before you go looking for them – either take an expert with you or read books about them first. It would be a real shame if you passed by the chance to photograph a rare butterfly and instead spent all your time on one

▲ The beautiful Comma butterfly is one of the most photogenic species. It is a relatively easy creature to capture with a camera, as it will sit and sun itself for ages.

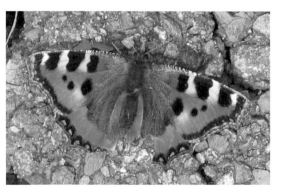

◄ If you are after a perfect butterfly specimen, make sure that you take a good look at it and check for damage. The bright colours on the Small Tortoiseshell shown here indicate that it is freshly emerged, but it has lost the tip of its lower left wing, and a piece out of the lower right one.

of the more common species. Doing some homework will also give you the chance to choose the best places to visit and when. Always bear in mind that you might need permission to enter certain sites – and also that it is illegal to pick wild flowers.

Flowers

Flowers can present many challenges to the photographer. For a start, they may not be in bloom for long. For example, certain tropical species may only flower for one night every few years. Others are past their best very quickly, or they may produce blooms for months on end. If you decide to enter this fascinating area of photography, start somewhere where you can set up a tripod in the peace and quiet, and also preferably in a spot sheltered from the wind. For most garden flowers, begin when the sun is high in the sky. This is because many flowers will track the sun, and others will begin to close their petals around mid-afternoon. It will also allow you to site your camera and tripod with reasonable freedom – having a shadow of the photographer in the picture will not improve it!

▲ Many photographers like to produce images where the subject is in clear focus, and the background is blurred, as can be seen here. I tried enhancing this photo, but could not improve on the original.

◄▲ Once you have taken a shot or two, the quickest way to check whether your focus was good is to zoom in on the centre of the flower and check whether all the pollen-bearing structures are crisp and clear.

Taming your subject

Animals and birds make very good subjects for
nature photography. The most obvious reason
for this is that, unlike people, you cannot put
them in poses or situations to your liking, so your
images are less likely to be overly contrived. Wild
animals and birds which are nervous around
human beings will be more difficult subjects to
photograph than, for example, the ducks on a
village pond, which may be used to people
coming close to them, perhaps in order to feed
them. However, you photograph wild creatures
in their own environment, doing their natural
thing, so the chances are that with practice you
will manage to take some truly life-like images.

As with all other forms of nature photography,
patience is a virtue, as is a calm approach. It is
no good running about trying to round up a
clutch of ducks to make up your photo
composition. You may just have to wait for the
right moment, as in the picture above right,
where the ducks have a complete disregard for
the laws on 'parking' on double yellow lines!
Birds and animals will often bring a real sense of
fun and enjoyment to your pictures, which is
what photography is all about, after all.

▲ One of the best ways to
begin photographing birds
is to find a local village
pond with tame ducks.

▼ The swirls in the muddy
water behind this duck
convey a sense of motion
and lend some extra
interest overall.

▲▶ The palm [above] forms a good central focal point for the composition, especially as the fallen trees conduct the eye towards it. On the right, the brightness at the top of the palm tree quickly gives way to darkness in the undergrowth.

Seeing the wood for the trees

Forests and woods can provide all sorts of subject matter – from the smallest fern to the mightiest of trees. If you keep a sharp eye out, there will also be animals around you, although most will sadly remain out of sight as well as out of shot, no matter how hard you search. Even if you only include plants in your image, a bit of patience and some good judgement can result in some excellent photographs.

These two photographs were taken in one of the last remaining areas of native Queensland rain forest, in Eastern Australia, where the canopy makes the undergrowth seem very dark indeed. If you are going to get good shots under such conditions, you must take the amount of available light into account.

Taking pictures for magazine adverts

If the object you want to sell is small, then set up an area where it can be positioned under good light. If this is close to where your computer is located, then some cameras have the option of using a program called RemoteCapture.

By linking the camera with the computer, RemoteCapture gives the photographer the ability to view images from the larger format of the monitor screen, as opposed to the smaller confines of the camera's own smaller LCD screen. This one can do in real time, while the shots are being taken. Your digital camera may not have this facility, but unless you are planning to advertise lots of objects in magazines or on the web, do not worry too much. The actual principles of taking photographs for publishing purposes will be the same whether you are photographing with the RemoteCapture facility or not, for example, good lighting conditions, suitable background and well positioned objects.

WATCH OUT!

Under the thumb
A series of thumbnails are shown along the top of the window, so you can review them to see which object position works best. Just click on the relevant image.

◀ Once the shot of the object you wish to sell has been taken, you can view all sorts of image information, including a histogram and a list of all the settings that were used on the camera.

Using RemoteCapture

If you want to see how your sale item is likely to look on screen or in a photo advert before you take the picture, then a facility like Canon's RemoteCapture will enable you to do this. If you have a mains adapter, then you can set your camera up on a tripod and take as long as you like to get exactly the shots you want. As soon as you have taken the shots, you can check them over – on a full-size monitor screen – without leaving your chair. If the final results are not good enough, you can simply delete them and try again.

The 'Viewfinder' mode in RemoteCapture allows you to see the actual image through the camera's lens. This means you can check that you have chosen a good angle for the shot, and whether the right amount of zoom has been used.

▲ Image quality is not reduced using RemoteCapture, so if you want to get close enough to capture some fine detail, it is not a problem.

MUST KNOW

Remote control

The first thing to do is to plug the camera into the computer, and then start the RemoteCapture program. At this point the screen will ask for the user to confirm the connection. This is basically to confirm that you wish to connect the computer to the camera.

Taking the shots

To take the photo, with RemoteCapture running, either click on the 'Release' button in the window on screen or hit the space bar.

As you take your photographs, the RemoteCapture screen keeps you well informed. At the top it tells you how many shots you have left and what quality setting you are working with. Below this, each tab calls up a page with even more information; for example, it tells you where the focus point is currently set, whether the macro facility and auto-focus assist light are on, and via a slide-bar it can also provide you with direct control over the amount of zoom to use.

▲ If your item is damaged in any way, make sure it is clearly visible, and give full details in the text. Do not try to hide the defects with image manipulation.

Photographic principles

As mentioned previously, if you do not have RemoteCapture, this will not affect your ability to take studio-type photos of objects indoors – the principles are the same. However, especially regarding items for sale, do not resort to image manipulation. Buyers will soon give you bad feedback if you try to hide any damage, which will ruin your prospects of getting good prices for

▼ If the item you are photographing has a shiny finish, you are likely to get flare if you use a flash [below left]. The photo on the right was also taken using a flash, but with careful positioning the flare was avoided.

Studio set-up

Studio photography need not be an expensive activity for the amateur photographer any more thanks to the digital camera. Most digital cameras allow previews to be shown of your pictures on the camera's LCD monitor so that you can review your results immediately. Cameras have a white balance setting that allows you to take pictures in most lighting conditions, which means you do not have to buy expensive studio strobe lighting to achieve great effects. The beginner is free to experiment and be imaginative with techniques learnt because, let's face it, they will not be wasting film costs...

▲ If you want to advertise a car for sale, you need to strike a compromise between making the shot interesting and it being informative. If the number plates are visible, it is a good idea to use your graphics package to blank out some or all of the numbers (see Chapter 5, page 89).

your items in the future. Honesty is the best policy when it comes to selling on the web!

Lighting is very important, and if you are photographing indoors, then you may well need to use a flash. This will inevitably cause a flare to appear on the image, which is a bright light from the flash that bounces off the object. If this is the case, either re-position the camera until the flare disappears or do not use the flash at all. If you can, take the photos outside in natural light, although pay attention to the position of the sun or you might encounter problems with flare again.

▼ Not all cars sold on auction websites – such as eBay – are full-size working models! Thousands of scale models are bought and sold every year. Good photographs will maximize their values in just the same way as they do with larger scale items.

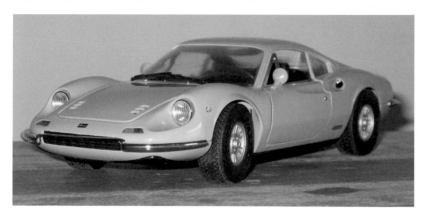

Photography at night

Taking successful images at night generally involves more time and trouble than most other forms of photography, due to the lack of natural light. Even if you are shooting in a city full of bright lights, your pictures will need careful thought.

Lights out

When the sun sets, it does not mean that you have to stop taking photographs. Many wonderful shots can be captured, providing that you use a bit of imagination and initiative. Indeed, the sunset itself can be a superb subject. Silhouettes of dramatic buildings are also a favourite, as are areas of towns and cities that have been lit for public use.

Judicious use of the flash can allow you to get good photographs of people – once again,

> **WATCH OUT!**
>
> **Still as the night**
> When taking pictures of buildings at night, use a tripod to make sure that the camera is kept as still as possible. This avoids blurring during a longer exposure.

it is a case of getting a lot of practice to learn the relevant lessons. Avoiding red eye is a prime example of one of the difficulties of night or low-light photography. Many digital cameras come with a built-in red eye reduction flash mode, which shoots off a flash of light fractionally ahead of the shutter. The subject's pupils contract just before the picture is taken, meaning the resultant image is free of red eye.

All sorts of effects can be achieved at night. You might end up capturing the blur of passing cars in a town or city without meaning to, simply from applying a longer exposure on the camera to compensate for the lack of natural light. You may even produce a dramatic blurring effect of the street lights, just because you did not mount the camera on a tripod but decided to hold it as steady as you could. A mistake in some people's eyes, but a stunning effect in others!

The bottom line is that just because it is dark, you do not have to put your camera away. Take advantage of the opportunities as they arise – and above all, do not be afraid to have a go and experiment!

▲ When the sun goes down, stunning shots can be taken. Here, aircraft vapour trails add interest, leading the eye to the centre.

▼ These two photos of a church in Eastern Europe are the same image. The one on the left is the original, taken at dusk, with the result that the detail of the church is lost; the one on the right has been brightened and enhanced using Paint Shop Pro.

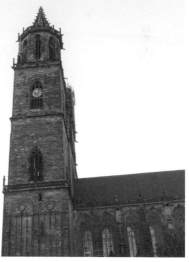

▶ # Commercial photography

If you become besotted with digital photography as a hobby and prove to be a proficient photographer, it is just possible that you might want to take photographs for a living. Here is a brief introduction to professional, commercial photography.

He who pays the piper...

If you have aspirations to earn your living with your camera, then it is worth knowing a little about commercial photography. Here we look at two very different aspects of the subject: firstly, there is the 'big shoot', in which a whole team of people descend on a venue armed to the teeth with equipment; and secondly, there is the role of the lone jobbing cameraman, travelling with the bare minimum of kit to fulfil some obscure request or other on a limited budget.

Big budget glamour photography involves the kind of photographic shoots that only large, international companies and bestselling

▲ Even though this shoot was taking place in bright sunlight, extra lights were strategically placed to remove shadows. Unfortunately, shooting in public places attracts attention, and onlookers are likely to get in the way.

◀ When big budget shoots take place, it is vital that every detail is perfectly prepared. Here we see a reflective screen used to help fill a scene with light.

publications can afford. No expense is spared on shoots like this. Specialist photographers with top-of-the-range kit are hired on huge expense accounts and are afforded extensive back-up teams, exotic locations of their choice, top models and every conceivable benefit. This really is a glamorous world, and it has made household names of some of the finest exponents of this kind of photography, such as David Bailey and Lord Lichfield.

At the other end of the scale, there is the lone commercial cameraman who shoots more modest assignments for a living – for example, me! Recently, I was asked to take a series of shots of two ice cream parlours and their surrounding areas for a book on the subject being produced by a local publisher. The commission was a last-minute affair, which meant I could not choose a date to suit the weather. It was also out of season, and I ended up getting absolutely soaked in the rain....

▼ Watermouth Castle in north Devon, England, on a cold, wet and overcast day. Commercial photographers often work to tight budgets and schedules and cannot always dictate the conditions in which they work.

▶ Creating simple websites

Between the pair of them, the internet and digital photography have revolutionized the ordinary person's ability to promote or advertise themselves or their pictures to anyone else with a computer, anywhere in the world.

If you want to show off your photographic prowess, what better way than to create your own website, where you can post your images for all to see? There are many sites that will give you a certain amount of web space for free, although you may have to display their advertising banner on your pages in return; the alternative is to purchase your own space. Either way, you will have to create one or more web pages. If you are feeling keen, you can hand-code your page using raw HTML code, but most people opt for a professional web creation package such as Macromedia's Dreamweaver.

A package like Dreamweaver comes with full instructions and is surprisingly easy to use. Many people imagine that creating a website must be a hugely complex and technically challenging exercise which can only be performed by

◀ To transfer your files from your computer onto the server where your website will reside, you need a special program, such as an FTP package. These can be downloaded for free from the internet. You will also have to enter various items of security information before you can log on.

◄ The internet plays host to millions of websites from all over the world, many of them created by amateurs. You can find just about all of them at www.google.com.

someone with a degree in computer science – but nothing could be further from the truth.

Hand-coding HTML

If you do not want the expense of acquiring specialist software, have a go at creating your own website using the basic code of HTML, as mentioned earlier. Although it is more complicated to set up a website in this way, if you are reasonably computer literate it will not be difficult to create a basic showcase for your images.

The easiest way to learn how to hand-code HTML is to find a website on the subject. One of the great things about the internet is the way that it self-sustains and self-perpetuates: tap in the words 'Creating simple websites' into a good search engine such as www.google.com and the URLs of a whole host of suitable sites will be made available to you. Some of these provide instructions in HTML coding and setting up a website for free, while others offer a more sophisticated service, which might entail paying for certain elements.

want to know more?

Take it to the next level...

Go to...
► **Displaying images** – pages 124–35
► **Digital video** – pages 170–80
► **Web resources** – page 186

Other sources
► **Press packs**
 observe the professionals at events
► **Photographic instruction centre**
 many colleges offer courses
► **Learning HTML**
 websites will guide you on the next step
► **Graphic design courses**
 many offer tuition in website design
► **Mobile phone retailers**
 will stock all the latest camera phones

digital

video

While the replacement of film cameras with their digital counterparts is an issue that still raises hot debate, the same cannot be said about the ousting of analogue video by digital equipment. This is partly because video is still a relatively new phenomenon, but also because people are already used to dealing with rapid changes in the technology.

Why digital video?

Digital video recorders are still relatively expensive, as the technology they rely upon is so new. However, there are many good reasons for investing in a digital camcorder.

Advantages of digital video

There are many reasons why digital video is a 'good thing', but the most important is simply that it produces much better quality images than analogue (film) video. This is because the storage method used is a lot more efficient – it improves the sharpness and colours tremendously.

Editing videos can be a thankless task, especially when there is a lot of footage to get through. Editing the old film formats required the patience of a saint, but digital film makes the job much simpler, and at times, fun, because the digital medium is so much easier to work with. This factor alone would justify the transition away from the analogue format, but there are lots of

▲ Devices like this analogue-to-digital converter will allow you to convert old video tapes quickly and easily.

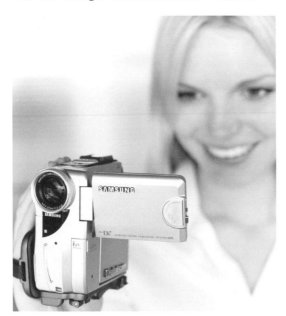

WATCH OUT!

Converting tapes
If you switch to digital video after using analogue tapes for any length of time, you will need to convert all your existing material into a digital form.

◄ There has been little resistance to change in the video market. This is probably because the technology has never stood still.

other benefits as well. For a start, digital camcorders are smaller and lighter as well as being able to produce much sharper images. Also, the fact that digital videos can be connected directly to a PC makes them eminently suitable for anyone who is computer literate.

Copying digital videos

One of the disadvantages of analogue videos is that when you copy them, the quality is degraded. Moreover, if you make a copy of a copy, you are likely to end up with very poor results indeed. With digital video, however, every copy is as good as the original, since computers can make error-free reproductions. This means that sending short video clips by e-mail or to websites is very easy, and when full length, high-resolution recordings are needed, it is simple to burn them onto CDs or DVDs.

Digital audio quality

Not only are digital images of a far higher quality, but so is the accompanying sound; digital camcorders can produce CD-quality audio recordings, especially when high performance microphones are used. If this is important to you, make sure that the model you are considering buying has the necessary connection sockets, or else you will have only the in-built microphone.

Manipulating video images

If you have manipulated images taken with a digital camera, you will know just what can be achieved. Ultimately, everything that you can do to a still image, you can also do to a video image, since they are basically the same thing. It is important to remember, however, that a video is comprised of 30 frames per second, so if you want to do any frame-by-frame manipulations, allow plenty of time for the project!

▲ Digital picture and audio quality will bring a freshness and vitality to the recordings you make that is unachievable with analogue tapes. Copying recordings is quicker and easier, too, with no resultant loss of quality.

MUST KNOW

Boxing clever
Some digital cameras can connect directly to a VHS video recorder, meaning that you can simply play an old tape and the camera will make its own digital copy.

Types of digital video camera

There are a bewildering number of different digital video cameras on the market. They range from budget models for a few hundred pounds to professional units costing tens of thousands of pounds.

Given the sheer range of choice in digital video cameras, it is obviously important to decide exactly what you expect from your video camera – and you much you are prepared to pay for it – before you embark on selecting the model that is right for you.

When examining the market for a suitable model, the first thing to do is to gain an understanding of the individual features that you need to assess in order to pick the right camera. It is important to remember that, as with digital 'still' cameras, it is the quality of the optics and the resolution of the image sensor that dictate the maximum achievable quality of any video camera. Do not be tempted to rush in to purchasing a camera without making a proper assessment of these elements. Additionally, remember that shop sales assistants will all too often 'steer' you towards models they want to sell, which are not necessarily suited to your purposes.

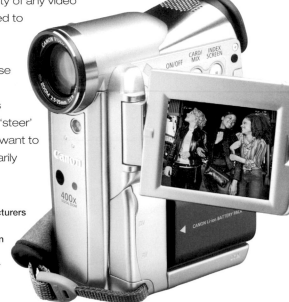

▶ Several international manufacturers make camcorders aimed at the domestic user. This is the Canon MV6iMC, which is an ultra-compact multimedia camcorder that can also take still images.

DIGITAL VIDEO

174

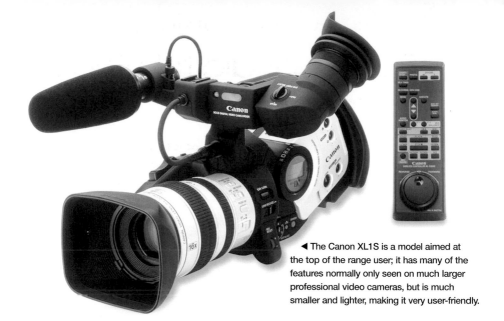

◀ The Canon XL1S is a model aimed at the top of the range user; it has many of the features normally only seen on much larger professional video cameras, but is much smaller and lighter, making it very user-friendly.

There are four main formats available on digital camcorders:

- **MicroMV** These camcorders record their footage as MPEG2 files – this is a high quality format with stereo audio which is the same as that used on DVDs. The tapes are very small, which helps to keep the overall size and weight of the camcorder to a minimum.
- **MiniDV** This format produces superb images and stereo sound from very compact tapes.
- **Digital 8** This format uses Hi8 tapes, which makes camcorders that use them a little larger than those which use MicroMV or MiniDV tapes. Nevertheless, the quality is still superb.
- **DVD-RAM** Camcorders that use DVD-RAM record their footage onto reusable double-sided discs. These are smaller than regular CDs, but some can hold considerably more information – indeed, they can have up to twice the storage capacity. The format itself produces high quality outputs, and depending on the make and model, one disc can hold up to an hour's recording at a time.

DIGITAL VIDEO

Features of digital video cameras

Like ordinary digital cameras, video digital cameras generally offer a number of high-tech features designed to improve the quality of your footage. These vary from camera to camera.

Zoom range

There are two types of zoom range that you will see quoted for a camcorder – optical and digital. As with still image cameras, it is the figure given for the optical zoom that you should pay more attention to. Digital zoom is a feature in which the image is magnified by special software, whereas optical zoom is that generated by adjustments to the lens position. The values that you can choose between for optical zoom start at 10x and go up to around 22x. For digital zoom they start at 32x and go up to around 1,000x, although the overall quality of the images produced at these higher figures is somewhat reduced.

▼ The zoom facility on a digital video camera can enable you to shoot dramatic footage like this in complete safety – well away from the action!

Weight

If you like to carry your camcorder with you a lot of the time, you may consider that its size and weight are among the most important factors when it comes to purchasing a new model. The lightest ones start at just over 300g (11oz), but as you add functionality the weight inevitably goes up. The heavier domestic models can be around 700g (1½lb), but those aimed more at the professional can reach nearly 3kg (6½lb)! Sizes start at around 45 x 110 x 80mm (1¾ x 4⅓ x 3in) for the ultra compact models, and go up to 223 x 214 x 415mm (8⅗ x 8⅗ x 16⅓in) for the largest cameras.

▲ The Samsung VP-W75D is a camcorder that uses the Hi8 format. It has a special processor which can produce digital zooms of up to 990x.

LCD viewfinder screen

If you have already used LCD viewfinder screens on digital cameras, you will know that they are much easier to use than conventional eyepiece viewfinders. For a start, you can let several people at once review footage, simply by holding the camcorder in front of them so that they can see the screen. Viewfinder screens also allow you to record scenes without making it too obvious that you are filming. Most people act differently when they know they are being watched, so it can really help you to capture natural activities by keeping the camcorder away from your eyeline. This is especially true where children are concerned. Check to see if the model you like has a colour or black and white viewfinder screen, if you have a strong preference for colour versions.

▲ LCD viewfinder screens allow you to use your camcorder much more easily than conventional eyepieces. This man is able to shoot low angles while remaining calm and relaxed, and as a result his footage will be less juddery and will have far better subject framing.

Digital stills

We have already seen how many digital cameras can also record videos, so it should come as no surprise that many camcorders can also shoot still images. If this is something that appeals to you, it is worth checking out the relevant details – especially the resulting image quality.

Editing digital video

Despite the technical advantages of owning a digital video camera, what you shoot will not always be exactly what you want. However, fortunately it is easy to edit digital footage.

MUST KNOW

Which editing package?

Digital video editing packages – like digital camcorders – offer a wide range of different features and consequently vary greatly in price. Decide which effects you want before buying a package.

▼ This is what is known as the 'environment' in Ulead's Video Studio. In the image below, one of the sample files that comes with the package has been opened.

Once you have captured some digital video footage and downloaded it onto your computer, you are likely to want to review and edit it. If you don't do this, chances are that you will end up with lots of unnecessary padding between the sections that you actually want your viewers to see. You may want to add titles to your film, and maybe a music soundtrack as well, or it might be that you want to add your own commentary. Whatever it is that you want to do, if you intend to edit your recordings, you will need some suitable software.

Ulead's Video Studio is a popular digital video editing program that is used by many camera users who are new to the subject. It is quick, easy and accessible and will not set you back a fortune.

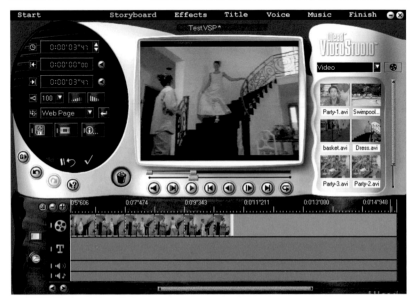

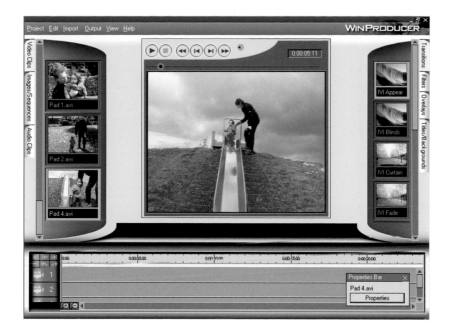

▲ Here we see WinProducer's working environment. On the left are thumbnail images which represent three .avi format film clips. The central window shows a single frame from one of the clips. The thumbnails on the right represent a series of standard movie effects.

Another video editing program that you can use to manipulate your camcorder footage is produced by InterVideo, and is called WinProducer. This is similar to many of the other packages on the market, in that you can select which movie files to import, and then edit or combine them in any manner of your choice.

All video editing packages perform the same basic set of functions, regardless of cost. They allow you to:

• Cut and paste video scenes into a tight, cohesive sequence with smooth transitions between sections.

• Separate audio tracks for background music or narration.

• Create titles that can scroll on and off screen.

• Fade your video slowly to or from black or white, or use dissolves and wipes.

• Use built-in filters to adjust exposure or colour filming errors such as over- or under-exposure or to make minor colour corrections.

WATCH OUT!

Don't overdo it...
Be careful not to overload your footage with too many different features. Good video footage should never be over-complicated and difficult to watch.

FireWire & digital video

Digital video files tend to be very big and consequently take time to download to your computer. However, data transfer technology is improving all the time.

FireWire

If you have a need to transfer large image or video files onto your computer, one of the best ways to do this is through what is known as a 'FireWire' link. Also called the i.Link by Sony and IEEE 1394 by other manufacturers, FireWire is a method of connecting two devices by a thin cable and sending high speed data between them. If you have such a capability on your camcorder, you will need to check out your computer to ensure that it has the necessary port. Unless it is a very recent model, you will almost certainly have to purchase and fit a special FireWire card in order to take advantage

▼ Some computers are aimed directly at users who want to work with multimedia in all its forms. This system comes from HP, and is called the 'Media Centre'. It has all the features you could want to work with so that you can easily manipulate your digital images, be they stills or video footage.

of this lightning-fast method of digital data transfer. You will also have to take care over the FireWire plugs and sockets that you select, as there are two types available – 4-pin and 6-pin.

One of the really useful features of FireWire is that you only need one port on your computer to accommodate the technology, as you can connect up to 63 devices in a row from only the one connection. This great advantage is made even better by the fact that you can plug and unplug these devices without having to turn the computer off – a facility called 'hot-swapping'.

As the resolution achieved by digital camcorders continues to improve, so the size of their recordings will also increase. This means that, if you are planning on using a digital camcorder, sooner or later you will need to get a FireWire card installed in your computer!

Specialist digital video

We have already looked at domestic camcorders in some detail, but at the other end of the scale are the much bigger, specialist digital television cameras and ultra high speed cameras used by professionals. A digital television camera is a general purpose unit costing tens of thousands of pounds. It is as good at capturing racing cars out on a circuit as it is for getting in close and recording interviews. An ultra high speed camera is far more specialized, however. It can record up to 80,000 frames a second, and is used for situations in which there is a need to record very high speed events for short periods of time. Filming the movements of engine components at high revolutions or the destruction-testing of cars and other vehicles is what this high-tech device was built for. It takes a highly experienced operator to get the best out of either of these cameras, but when used properly, they produce superb results!

▲ This is a professional video camera used for all manner of productions for television. It is very expensive and very heavy!

want to know more?

Take it to the next level...

Go to...
▶ **Image storage** – pages 22–9
▶ **Image editing** – pages 78–99
▶ **Displaying video images** – pages 124–5

Other sources
▶ **Film and video clubs**
 you may need to be a member
▶ **Video hire shops**
 learn tips from the movie professionals
▶ **Video and DVD consumer magazines**
 full of product reviews and advice
▶ **Useful websites**
 do an internet search for 'digital video'
▶ **Books on digital video**
 do your research first before buying

▶ Glossary

A

Alkaline batteries Non-rechargeable batteries that offer high performance at low cost.

Aperture The size of the hole through which the image is focused on the sensor.

Aspect ratio The ratio of an image's height to its width.

Autofocus A facility in which a camera or camcorder automatically finds the best possible focus for the image.

B

Back-Filled This means the CCD's housing is filled with argon to prevent condensation.

Bitmap/Bmp An image format popular in the early days of PCs, but still used as the native format by the Windows operating system.

Black & white mode This takes all the colours out of an image to mimic black & white film.

Blog This term is short for 'Web log', and is a web page or site that represents a kind of internet diary.

Bluetooth A special technical standard which allows wireless communication between devices.

Byte A unit of data equal to the amount used to represent one character.

C

Camera obscura Image formation caused by light passing through a pinhole.

CCD This is an image sensor; CCD stands for 'charge-coupled device'.

Clone brush This is a tool used by graphics programs to retouch images.

CMOS A sensor; CMOS stands for 'complementary metal oxide semiconductor'.

Colour depth The number of colours in an image factor. This governs the quality of your images.

CompactFlash A type of memory card used in some digital cameras.

Cropping A process used in graphics programs to cut away unwanted portions of an image.

D

Daguerreotype A very early method of generating photographic images.

Dialog box A window that is shown by a program that requires some kind of user input.

Digital zoom A way of magnifying an image using software techniques.

Dpi Dots per inch – it is a measure of the quality of a printed image.

Driver A piece of software that is used to make a device such as a printer work properly.

DV-format A high quality format used by some camcorders.

Dynamic range A measure of how a sensor records the bright and dark areas in a digital photographic image.

E

Exposure The amount of light that is allowed to reach the image sensor which is controlled by the shutter speed and aperture setting.

F

Firewall A special system for keeping one or more computers safe from unwanted access.

FireWire A special method of connecting devices in which data can be transferred at high speed.

Focus The adjustment of the lens to make a subject or scene appear crisp in an image.

Format conversion A method of changing the manner in which an image is stored.

FTP Stands for 'File Transfer Protocol', and is a method of sending data across the internet.

Frame rate ...of a CCD is a measure of how fast a sensor can operate.

G

GIF An image format popular with website developers. It stands for 'Graphics Interchange File'.

Gigabyte (GB) A measure of the size of an amount of data, it equates to 1,000 megabytes.

H

Histogram This is a special chart that represents some kind of image information.

HTML code A computer code used to create some web pages.

Hyperlink a symbol on a computer screen that can be clicked to link to another location.

I

Incandescent A setting used to compensate for colour shifts caused by certain lighting.

Interpolation A process to improve the optical resolution of an image using software.

Iris An adjustable orifice that controls the amount of light that enters a camera.

ISO speed A number that specifies the speed of a silver-based film.

J

JPEG or JPG The most commonly used image format.

K

Kilobyte (KB) A measure of the size of an amount of data, it equates to a tenth of a megabyte.

L

Landscape mode A setting used for taking panoramic views of landscapes or wide objects.

LCD screens Liquid crystal displays used as viewfinders, and increasingly as monitors.

Light temperature This is a measure used by photographers to describe an image's colour bias.

Low Sharpening A setting used to change the sharpness of an object's outline.

M

Macro mode A special setting for taking close-up photographs.

Megabyte A measurement of data equivalent to one million bytes.

Megapixel This refers to a CCD (or CMOS) sensor that has at least one million pixels.

Memory card A small removable data storage card used by most digital cameras.

Monochromatic An image presented in black and white; also known as greyscale.

N

Neutral mode The opposite of vivid mode, it records an image with no colour enhancement.

Nickel-cadmium batteries Durable rechargeable batteries for medium load use.

Nickel-metal hydride batteries Durable rechargeable batteries for high capacity use.

O

Optical zoom True image magnification achieved by repositioning the lenses.

P

Palette An array of colours or tools used in graphics programs.

Photosensitive This means that a chemical or sensor reacts to the presence of light.

Pixels The individual elements that go to make up a digital image – short for 'picture element'.

R

RAM Special electronic memory used by computers, it stands for 'Random Access Memory'.

RAW format A special format that uses no compression for the highest quality images.

Red eye Red eyes in images caused by the response of the human eye to electronic flashes.

Reformat A reorganization of the data storage on memory cards – it also erases all images.

Resolution A measure of the picture quality of an image – the higher the resolution the better.

S

Scanner A device used to create electronic representations of a flat item, such as a document.

SD Card A type of memory card used in some digital cameras – 'SD' stands for secure data.

Self-Timers A facility that triggers the shutter release after a set amount of time.

Sepia mode A setting that records images in various sepia tones and mimics the style of old photographs.

Shutter speed The speed at which the shutter opens and closes.

SmartMedia card A type of memory card used in some digital cameras.

Stitch mode A facility that combines a series of images into one much larger image.

T

Tape format A type of data storage used in some digital camcorders.

Thumbnails A very small version of an image used by photo galleries and web pages.

TIFF An image format widespread in publishing – it stands for 'Tagged Image File Format'.

Tripod A three-legged device used for supporting a camera or camcorder to prevent shake.

TTL A feature of SLR cameras, the viewfinder looks 'Through The Lens'.

Tungsten A setting used to compensate for colour shifts caused by tungsten electric lighting.

U

USB port A special port used to connect devices to a computer without turning it off. 'USB' stands for 'Universal Serial Bus'.

Ultra SD A type of memory card used in some digital cameras.

Ultra II CompactFlash A type of memory card used in some digital cameras.

Uninterruptible Power Supply A device used to protect a computer against power failures or surges, known as a 'UPS'.

V

VHS A format used for recording video films.

Viewfinder A device used to see where the camera lens is pointing – it can be optical or LCD.

Vivid mode A special camera setting used to enhance the colours of any recorded images.

Video mode A setting available on some digital cameras, it allows short video recordings.

Virus A malicious program usually sent via e-mail that can damage data or even hardware.

W

Wet plate collodion photography A process used by very early pioneers of photography.

White balance An adjustment made to the colours in an image to improve their accuracy.

X

XD card A type of memory card used in some digital cameras.

Z

Zoom A facility that adjusts the lens to make an image seem closer than it is.

Need to know more?

Unless you only ever use a direct link from your camera to a printer, it more or less goes without saying that you have access to a computer. It makes sense, therefore, to use it as a portal to the enormous amount of information about digital photography which is available from websites via the internet.

Product manufacturers' web addresses
Adobe (Photoshop and more): www.adobe.com
Canon UK's site: www.canon.co.uk/
Compaq: www.1.hp.com/
Duracell (batteries and more): www.duracell.com
Epson UK's site: www.epson.co.uk/
Fujifilm UK's site: www.fujifilm.co.uk
Gitzo (tripods and monopods, etc.): www.gitzo.com/
Gitzo's UK distributor: www.hasselblad.co.uk/
Hewlett Packard: www.hp.com/
IBM UK's site: www.ibm.com/uk/
InterVideo (WinProducer video editing software and more): www.intervideo.com
Ipswitch (FTP software): www.ipswitch.com
Jasc (Paint Shop Pro and more): www.jasc.com
Kodak: www.kodak.com
Macromedia (Dreamweaver web creation software and more): www.macromedia.com
Microsoft (software and more): www.microsoft.com
Nero (CD burning software and other related materials): www.ahead.de/en/index.html
Nikon UK's site: www.nikon.co.uk
Nixvue (handheld storage devices and more): www.nixvue.com
Nokia: www.nokia.com
Pacific Digital (photo frames, etc.): www.pacificdigital.com/
Powerware UK's site (uninterruptible power supplies): www.powerware.co.uk/
Pure Digital (disposable Ritz Dakota cameras): www.puredigitalinc.com
Samsung UK's site: www.samsungelectronics.co.uk
SanDisk (memory cards, readers and more): www.sandisk.com
Sony: www.sony.com/
Ulead (Video Studio software and more): www.ulead.com

Websites for enthusiasts
A history of photography from its beginnings till the 1920s:
www.rleggat.com/photohistory/
A site for Brownie enthusiasts: www.members.aol.com/Chuck02178/brownie.htm
Digital Photography Review (digital photography news and reviews):
www.dpreview.com/
Megapixel (monthly digital camera web magazine): www.megapixel.net
Outdoor Eyes (for outdoor photographers): www.outdooreyes.com/
Photo Net (discussion forums, reviews, etc.): www.photo.net/
Shortcourses (a complete digital photography course): www.shortcourses.com/
The Classic Camera: http://www.cosmonet.org/camera/index_e.html

Useful addresses
Amateur Photographer's Association
www.photoassociation.com

Australian Centre for Photography
257 Oxford Street, Paddington, NSW, Australia 2021
www.acp.au.com/

British Institute of Professional Photography, Fox Talbot House,
Amwell End, Ware, Hertfordshire SG12 9HN
Tel: (44) 1920 464 011
E-mail: bipp@compuserve.com

Canadian Association for Photographic Art
CAPA HEAD OFFICE
31858 Hopedale Avenue
Clearbrook, B.C., V2T 2G7, Canada
www.capa-acap.ca/

International Freelance Photographers Association
IFPO Order Dept., P.O. Box 777, Lewisville, NC USA 27023-0777
www.aipress.com/

North American Nature Photography Association
10200 West 44th Avenue, Suite 304
Wheat Ridge, CO 80033-2840, USA
www.nanpa.org/

If you need it, there is more information about useful international addresses
relevant to digital photography at:
www.profotos.com/education/referencedesk/organizations/index.shtml

▶ Bibliography

Aaland, Mikkel, & Rudolph Burger, *Digital Photography* (Random House, New York, USA 1992)

Breslow, Norman, *Basic Digital Photography* (Focal Press, London, England 1991)

Brown, Michael J., *Photographic Enhancement, Manipulation, and Special Effects with Personal Computers: An Introduction to Image Processing* (N. C. Brown, Germantown, Wis., USA, 1991)

Busch, David D. *Digital Photography* (MIS Press, New York, USA, 1995)

Davies, A & P Fennessy, *Digital Imaging for Photographers* (Focal Press, London, England 1998)

Farace, Joe, *Digital Imaging: Tips, Tools, and Techniques for Photographers* (Focal Press, London, England 1998)

Fitzharris, Tim, *The Audubon Society Guide to Nature Photography* (Little, Brown, Boston, MA, USA: 1990 Pub TR721 .F58 1990)

Gardiner, Jeremy, *Digital Photo Illustration* (Van Nostrand Reinhold, New York, USA, 1994)

Glenwright, Jerry, Digital Photography Step-by-Step (Collins, London, England 2002)

Grotta, Sally Wiener, *Digital Imaging for Visual Artists* (Windcrest/McGraw-Hill, New York, USA, 1994)

Holzmann, Gerard J., *Beyond Photography: the Digital Darkroom* (Prentice Hall, Englewood Cliffs, USA, 1988)

Izzi, Guglielmo, *The Complete Manual of Nature Photography* (Harper & Row, New York, USA, 1981. Pub TR721 .I9913 1981)

Kirkland, Douglas. *Icons: Creativity With Camera & Computer* (Collins Pub., San Francisco, USA, 1993)

Larish, John J. *Digital Photography: Pictures of Tomorrow* (Micro Publishing Press, Torrance, CA, USA, 1992)

McMahan, Robert, *Pixel Photography* (Olive Press, Lake Hughes, CA, USA, 1993)

Meyer, Pedro, *Truths & Fictions: A Journey from Documentary to Digital* (Aperture, New York, USA, 1995)

Pike, Jayna, *An Introduction to Computer Graphics Concepts: From Pixels to Pictures* (Addison-Wesley Pub. Co., Reading, USA, 1991)

Ritchlin, Fred, *In Our Own Image: the Coming Revolution in Photography* (Aperture, New York, USA, 1990)

Sparkman, Russell, *Essentials of Digital Photography with CD* (New Riders Publishers, Indiana, USA, 1997)

Tinsley, John, *Guide to Digital Imaging for the Freelance Photographer* (BFP Books, 1997)

West, Larry, *How to Photograph Reptiles & Amphibians* (Stackpole Books, Mechanicsburg, PA, USA, 1997. HERP TR729.R47 W47 1997)

Index

Acknowledgements

The publishers wish to thank the following manufacturers for supplying images for inclusion in this book.

Ahead Software: 26(T); Apple Macintosh: 113, 114(T), 118; Canon: 12(T), 14, 16, 17(B), 19, 104, 105, 110, 120, 125(B), 174, 175; Epson: 108(B); Fujifilm: 36(T), 46(B), 48(B), 108(T); Hasselblad (UK): 44(L&R); Hewlett-Packard: 112, 119(T), 134(T), 180; InterVideo: 179; Microsoft Corporation: 114(B); Nikon: 17(T), 48; Nixvue: 127; Nokia: 130(T&B); Pacific Digital: 136; Powerware (Invenys Company): 137; Samsung: 126(R), 134, 172(T&B), 176 ; SanDisk Corporation: 22(T), 24(B), 25(B), 26(T), 45, 124; Ulead: 178.

Key: T=Top; B=Bottom; L=Left; R=Right

The author would like to thank Jonathan Watts for his kind assistance and advice in compiling this book, and would like to dedicate this book to his daughters Gemma and Carina.